TATTOO

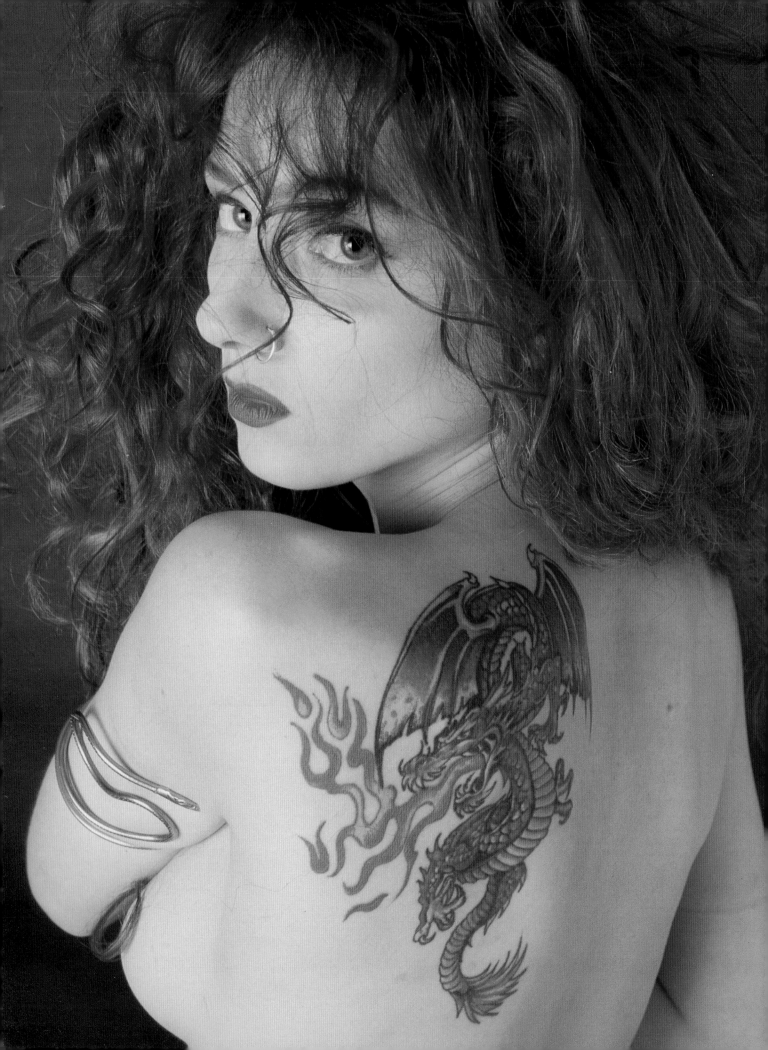

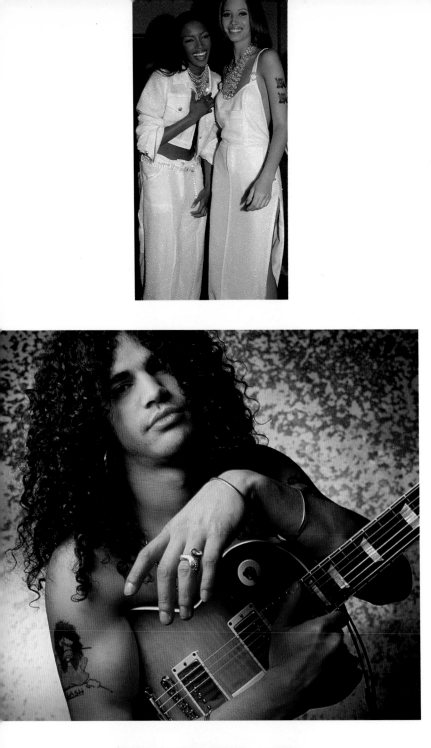

TATTOO

THE EXOTIC ART OF SKIN DECORATION

Michelle Delio

ST. MARTIN'S PRESS

Project Editor Lorraine Dickey
Edited by Nicky Hodge
Art Direction by Bobbie Colgate-Stone
Designed by Cooper Wilson Design
Picture Research by Kay Rowley
Production by Sarah Schuman

Produced by Carlton Books Limited

CIP data for this book is available from the Library of Congress.

ISBN 0-312-10148-1

First U.S. Edition: February 1994

10 9 8 7 6 5 4 3 2 1

CONTENTS

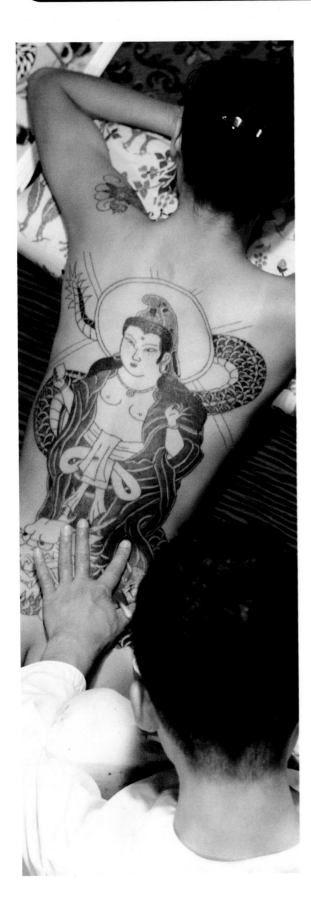

introduction

Many years ago I walked into a tattoo studio for the first time and fell in love — with both the artist and the art. Although my romance with the tattooist quickly faded, that initial infatuation with tattooing has since blossomed into a full-scale obsession.

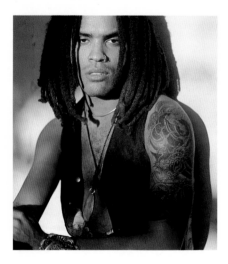

The skin of the human body has always fascinated artists, although skin remains one of the most difficult mediums for an artist to work with. A conventional canvas lies still and flat; it will not sweat, swear or want to share its innermost thoughts on the meaning of life with you. For tattooists not only have to be artists, making instant and vital decisions that will affect people for the rest of their lives, they are sometimes called upon to be therapists and social workers as well.

A great tattoo is the result of a mutually respectful partnership between a client and a professional tattoo artist. Beautiful tattoo work speaks of an investment in time, money,

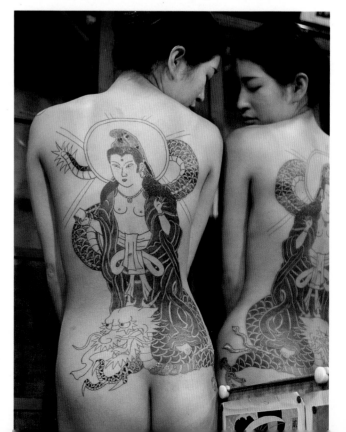

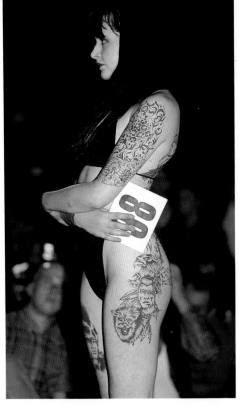

patience, thought and talent. Unlike those who merely buy paintings or rare objects, people who collect tattoos earn their art. It never ceases to amaze me that there are people in the world who will spend a few hundred dollars on a night out, but who will then balk at spending the same amount on a tattoo that's going to be on their body forever.

Tattooing is an exotic and mysterious art form whose roots date back to prehistoric times. Getting a tattoo in this society is still regarded by some as tantamount to embracing an 'outsider' culture; indeed in some parts of the world tattooists are prohibited by law from working. Tattoos nowadays however are becoming increasingly acceptable; there is not just one 'type' of person who may get a tattoo, there are no barriers of sex, age or class in tattooing.

I've written this book with deep respect for an art form that, over a number of years, has transformed my body and my life. As a tattoo collector, I am grateful to have access to some of the world's most creative artists; men and women who are ready and capable of translating my dreams and visions into beautiful pieces of living art. This book provides a key for you to unlock your own wildest fantasies, turning them into something that you can be proud to wear every day of your life. I hope the following chapters prove useful to anyone attracted by the idea of getting a tattoo, but who perhaps lacks either the necessary knowledge or courage to carry it through. I also hope that *Tattoo* gives an inspirational insight into some of the world's finest tattoo collections.

Michelle Delio

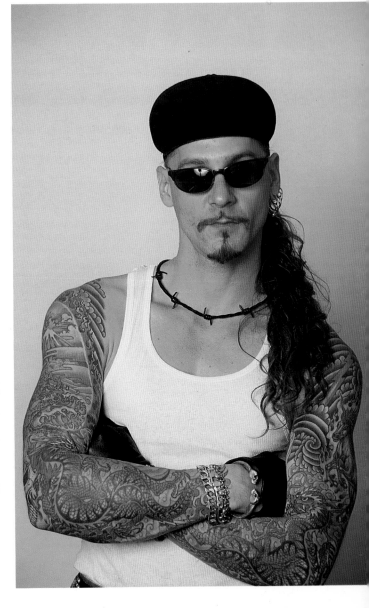

tattoo

For thousands upon thousands of years, human beings have been trying to feel at home, both on this planet and in our own bodies. We search for the meaning of it all, contemplating our navels to fathom the mysteries of the universe, as well as to determine who exactly it is trapped inside our suit of skin.

Tattooing is about personalizing the body, making it a true home and fit temple for the spirit that dwells inside it. I have noticed that the more symbols that I have inked into my flesh, the more grounded and settled into my body I feel. By treating my body as something to be altered for my pleasure, I make it both less and more sacred; less because I do not choose to accept it as 'perfect the way God made it,' and more because I honor this gift of flesh enough to care for it, nourish it, and decorate it. Tattooing, therefore, is a way of keeping the spiritual and material needs of my body in balance.

Although I've spent the better part of my life in tattoo shops, I didn't get my first piece until I was 25. Through being married to a tattooist, and involved in managing our tattoo shop, I was exposed to both the best and worst of tattooing. Some people who came in wanted beautiful designs that they'd obviously put a great deal of thought into selecting, and often these folks left with wonderful pieces of personal art. However, there were also those who said they "just wanted a tattoo" and quickly selected something from the flash designs on the walls. I'm not saying that you can't find great tattoos hanging on the walls of a tattoo shop, for there are some beautiful flash designs available and we had some fine examples on display. I'm referring here to the people who would walk in, spend a scant five or ten minutes looking at the designs, and then pick the smallest piece they could, often requesting that it be scaled down further so that they could be guaranteed a price cut. Then, saddest of all, were the people who had gone to some uneducated butcher who figured he was a

Detail of oriental-style back piece (left). Back piece featuring woman's body by Little Vinnie Myers of Maryland (right).

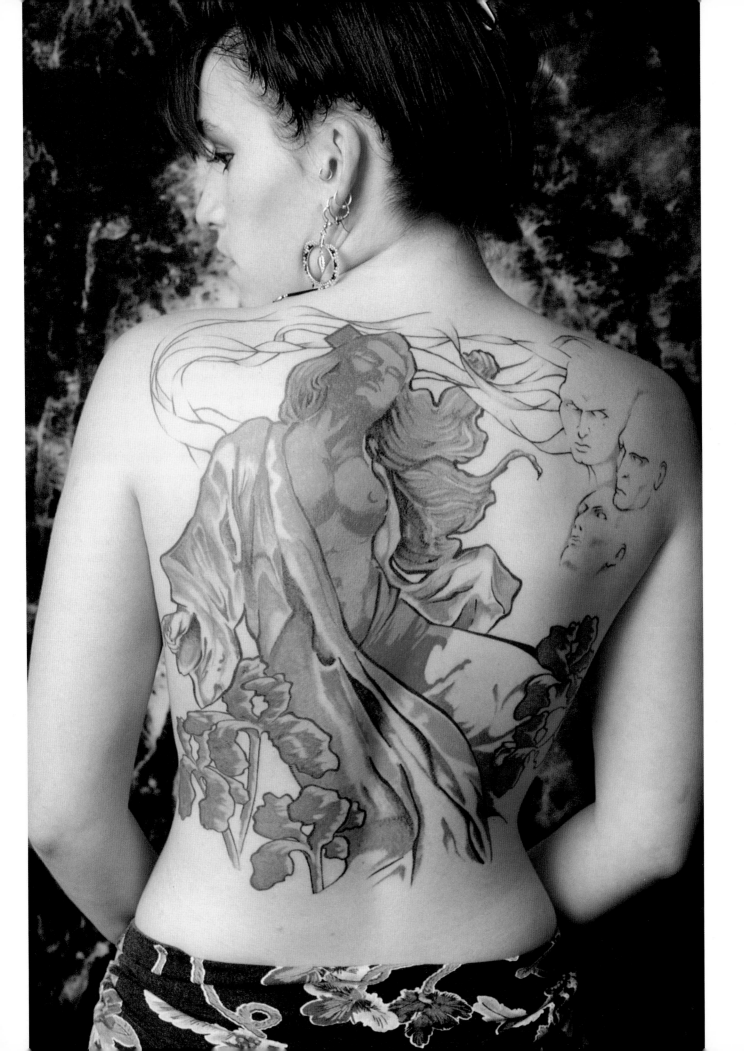

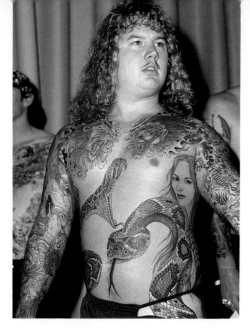

great artist because he managed to get his hands on some tattooing equipment. These people not only had hideous designs inscribed on their skin, but also had scar tissue, infections and other residual problems to contend with.

Although my heavily tattooed friends teased me about my 'virgin' status, I took the art seriously enough to realize that getting a tattoo is an experience unlike anything else. However, the fact that it is an irrevocable lifetime commitment scared me, as it ran contrary to my belief that embracing and inviting change is a vital part of living an interesting life. I just couldn't see how I could choose a tattoo design that I would still love in ten years, or in as many months, or even days.

IF YOU'VE GOT IT, FLAUNT IT

I wasn't at all afraid that I would outgrow the tattoos themselves; that I would suddenly wake up one morning and decide that I wanted to be a leading member of 'straight' society, where my tattoos would be utterly taboo. I knew that being tattooed means accepting that you're part of an 'outsider' lifestyle, but nothing in the values and mores of mainstream society has ever had any attraction for me anyway. Since being tattooed, I have really enjoyed wearing clothing that reveals my tattoos when traveling first class in an aeroplane or staying at a fine hotel, as it is a great way to show people that being tattooed doesn't prevent you from having a successful career or from appreciating the finer things in life. It is also a lot of fun to watch people trying to work out the appropriate pigeonhole in which to file me. They usually decide I must be a rock star, as how else could I have managed to amass enough money to be there with them?

If being tattooed was never going to stop me from doing whatever I wanted to do, or going

*T*attoo fan Joe Piole's award-winning collection, with work by Jack Rudy and Craig Hemlich (top left). Women often have some of the most interesting tattoos (bottom right).

wherever I wanted to go, I was still troubled by the permanence of the art form. After all, some of the things that I thought were 'high art' when I was 18, I now look back on with derision. I have to admit being one of those that went through that pastel, unicorns and moons, 'new age' art stage that most teenage girls seem to latch onto eventually. Although the thought of this makes me shudder now, I could foresee the same thing happening in time with a tattoo; eventually coming to despise any youthful obsessions that I had etched permanently into my skin. A distinct and scary possibility, but one that I knew I had to come to terms with as, above all, I wanted a tattoo of my own.

It was the arrival of my 25th birthday that finally

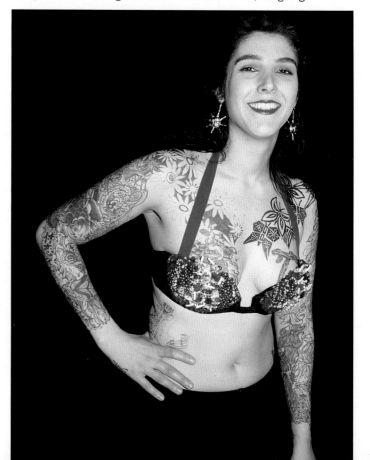

settled the matter, as I decided I really wanted to get a tattoo to mark this quarter-century point of my life. A few months before the big day I began the process of finding my tattoo.

FINDING THE RIGHT TATTOO FOR YOU

I went about choosing my tattoo a little differently from most of the people I know. Seeing so many cover-up casualties in the shops had made me think long and hard about what this tattoo should be. I wanted to find a symbol that would not only depict the first 25 years of my life, but would also have enough depth, or layers of meaning, to get me through the next 25 - and beyond. I wanted a tattoo that I would understand even better on my 50th birthday than I did the day I got it.

> **"*I WANTED A TATTOO THAT I WOULD UNDERSTAND EVEN BETTER ON MY 50TH BIRTHDAY*"**

Sometime during this process I also happily came to understand that although you can 'outgrow' a tattoo, it's still valid when it becomes less a symbol of who you are and more a depiction of what it took to get you where you are now. Looked at in this way, tattoos become a rite of passage with the power to freeze-frame time. Tattoos can, therefore, be as potent as the most ancient of magical talismans, bestowing on each individual a reminder of past triumphs, conquered pain, and lessons learned. They can remind you of that special moment when you had a clear idea of who you really are. This, to me, is tattooing at its best.

I searched for my tattoo everywhere. I spent a great deal of time looking through magazines, books, museums and any other visual resource to which I had access. As it happened, my final design was the first idea that I had thought of.

For years I had been collecting various depictions of Pan, the goat God of ancient Greece. The half-animal, half-man archetype really appealed to me because I think people should work towards integrating their rational, thinking, civilized selves with their instinctive, animal, untamed selves. Undoubtedly, we all need a little more of that animal vigor and vitality in our lives and, by having the image of Pan inked into my skin, I hoped to invoke the spirit of this primordial God into the 20th century.

It was easier to settle upon the particular style of work in which to have my tattoo. I opted for black and gray work, although I did not like this style when I first saw it as these tattoos often looked strangely unfinished to me, almost as if the artist had laid down the outline and the shading, then got bored and wandered off. However, after a while I became accustomed to the look, and once artists had refined the technique, I grew to like it very much.

After making these key decisions, I needed to find a tattoo artist. I didn't simply pull out the phone book and call the nearest shop, but spent time looking through tattoo magazines as well as going to a couple of

Lenore shows off her first tattoo, a bold, colorful back piece by Guy Aitchison, an influential American tattooist (below).

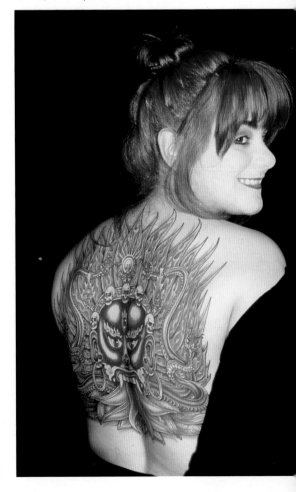

11

conventions. That's where I met the man who has been primarily responsible for turning my body into a work of art (albeit a rather out-of-shape masterpiece) ever since.

Obviously I wanted to find a tattoo artist who was responsible for creating some beautiful work, as well as someone whose shop met the highest standards of cleanliness. However, I also wanted someone that I'd feel comfortable with, who wouldn't get annoyed with my many questions and whose opinions and talent I completely respected. To meet these conditions, I was more than willing to travel, but luckily the tattooist I chose, Dan Williams, lived in Bridgeport, Connecticut, which is only a short drive from my home in New York.

I called Dan and explained what I was after. "No problem," he said. "Send me a picture and I'll draw it up for you."

In the end I sent him about ten pictures because I wanted a composite image taking, for example, the face from this design and the body from that one. Again, Dan was reassuring, telling me that he knew what I wanted.

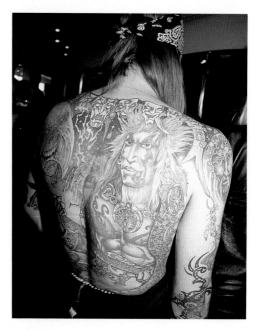

A 'living canvas' exhibits a full-color back piece at a tattoo convention (above). Jerry Szumski from New Mexico shows his mastery of black and gray work, one of the most demanding tattoo styles (page 13).

GETTING UNDER MY SKIN
I arrived at his tattoo studio on the appointed day, smoked a couple of cigarettes and waited. Danny showed me a stencil of my design. His earlier confidence was not misplaced, as the final image was exactly right. I also needed another cigarette. After a while he asked me if I was ready. I said I thought I was, just as soon as I had finished this last cigarette.

"Nervous, are you?"

"Who, me?"

I was, of course, and in a big way. Mainly, I guess, because I didn't know what to expect. I'd seen people who just winced a little as they got tattooed, people who grimaced horribly, people who fell asleep, and there was even one poor soul who fainted. Even though I was about to have the tattoo placed on a traditionally easy spot (my upper back), I'd seen folk getting tats in the same spot who turned a sickly green and others who didn't register any pain at all. I really didn't have a clue how I might react.

Eventually I managed to tear myself away from my growing fascination with ruining my lungs and get into the chair. The stencil was applied after the area had been cleaned and we were finally ready to get on with the business at hand. I was feeling rather shaky so Dan said he'd do one line and stop, just so I could see how it felt. I heard that familiar buzzing of the tattoo gun. We'd begun.

It did hurt, but only a little. It stung a bit, burned a bit, and was a lot more annoying than it was out-and-out painful. Certainly not the big deal that it is made out to be.

During the couple of hours it took to complete the tattoo, Dan kept me posted on how far along we were, which helped to make time pass by more quickly. I'll spare you all of his jokes, which were along the lines of "Do you mind if your Pan has ostrich legs? Yes? Oops...well, sorry, it's too late now."

Before too long I was out of the chair and admiring my new tattoo. It was covered by a bandage and, a few hours later, I felt as if I'd spent the day at the beach and got a bit too much sun. The most annoying part of the

whole procedure was having to apply that damn healing ointment at regular intervals. After ruining several blouses, I gave up trying to look good and dragged out my oldest T-shirts for the duration. The tattoo healed in a week.

A word of warning though: tattoos can be very addictive. I have gone back for seven more in the last five years.

It's not often that you get exactly what you want in life, but my tattoos have been the exception to that rule. Choosing the right tattoo artist and the particular images that I have inked on my body were not decisions that I entered into lightly. As I'm fascinated by the history and breadth of the art, I've elected to have my pieces done in all the major tattoo styles. I have a fineline color piece of a flower on my upper chest, a tribal piece on my leg, another very modern and bold floral piece wrapping around my ankle, a graffiti piece of my son's name going down my right arm surrounded by oriental-style black and gray waves, and a very traditional piece on my back. Most were done by Dan, but the tribal and graffiti pieces were inked by Jonathan Shaw in New York and the floral piece on my leg is by Guy Aitchison from Chicago. It may sound like rather a hodgepodge but the pieces were carefully placed, and the whole thing was planned in advance so they actually work together quite well. Will I decide to get some more tattoos? The answer to that is a resounding "yes."

INSPIRED FROM WITHIN When the designs are chosen

with care, tattoos have a power and magic all their own. They decorate the body but they also enhance the soul. I encourage you to look deeply within yourself to find your tattoo design, to discover the real passions and pleasures that spark your life. Get tattooed when you know enough about yourself to be able to translate your wildest dreams and deepest fears into images. Only you can decide when you are ready and brave enough to wear your most private fantasies on your flesh, for all the world to view.

My tattoos reveal the truth to those who have eyes to see. They remind me of who I really am when I am lost in the confusion of day-to-day living. They are both ancient gnarled roots linking me to my past and bright wings to my future. They tell my story; they are the illustrations of my personal myth. They make me feel strong, and at the

same time they remind me of my mortality. My art will not hang in some dusty museum. I will take my tattoos with me as companions on the next great adventure.

Shortly after I got my first tattoo I was given the opportunity to edit a magazine dedicated to showcasing skin artistry. It was originally planned to be a

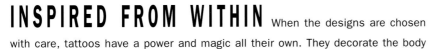

> "*TATTOOS CAN BE VERY ADDICTIVE. I HAVE GONE BACK FOR SEVEN MORE IN THE LAST FIVE YEARS.*"

'one-shot' deal; a single special issue of the motorcycle magazine I was then involved in producing. The sales of that fledgling issue of *Tattoo Revue* magazine exceeded our marketing department's wildest expectations. Now *Tattoo Revue* is a bi-monthly publication that even has its own spin-offs, *Skin Art* and *Tattoo Expo*. Through editing the magazines, my appreciation for the art of tattooing has continued to grow every day. I am constantly amazed at the quality of the work tattooists are creating, and the more I learn about tattooing, the more I realize how much there is still to know.

THE BODY AS A LIVING CANVAS

I have always been intimidated by 'art,' feeling that I needed a certain type of education to even begin to understand it. Now I realize that art can be anything visual that provokes a reaction and, by prying open a door in your mind, it can take you to somewhere that you never knew existed. Of course something that thrills me to the bone may elicit nothing more than a yawn from the next person who views it. This just doesn't matter. A piece may be a disaster when judged in the context of formal artistic guidelines, but if it inspires a sense of wonder and joy in the person who is looking at it or wearing it, then it has fulfilled its purpose. I accept that art works on many levels, and that some art is *filet mignon* for the mind whereas some is sugar candy. However, the point is that we should all strive to educate ourselves to be able to get the most out of what we're looking at.

> "*YOU DON'T BUY A TATTOO AS AN INVESTMENT. YOU DON'T GET THE ONE THAT MATCHES YOUR COUCH.*"

A piece that flows with the shape of the back (below).

Detail from a tattoo by Ed Hardy (page 15).

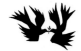

I get a great deal of joy from looking at a beautifully executed tattoo, having spent years learning how to really look at them. I've also enjoyed looking at pieces that are not classically wonderful, but do have a great deal of style and heart. Tattoo masterpieces have an almost indefinable honesty, power and depth. Sometimes the most technically accomplished tattoos just stop short of being magical pieces of art. It could be that the artist was trying too hard. Whereas old tattoos from the Thirties and Forties, while crude in comparison to today's work, often have a spirit that makes them come alive even on a dusty old sheet of flash art.

Tattooing is one of the oldest of all art forms, with the skin of the human body having been marked and decorated since the earliest cultures inhabited the planet. It is an art that is accessible to everyone, without any of the pretensions and stupidity that are the hallmarks of the 'fine art' world. You don't buy a tattoo as an investment. You don't get the one that matches your couch. You don't need a manifesto to understand what a particular piece is about. You don't need art critics to analyze it and explain it to you. Tattooing is a personal, passionate art form that encourages you to get an image that means something to you, however banal it may look to the rest of the world. Even though I have been critical of people who get simplistic, predictable imagery applied to their skin, in my heart I believe that every tattoo has a special meaning to the person who is wearing it. The tattoo, then, is no longer just a personal and permanent body decoration, but an artistic statement in its own right. Indeed, the ability to create a great tattoo is an art, and a lot of the work using the medium of skin deserves as much respect and intensive study as many of the canvases to be found hanging in a gallery.

Tattoo was written with two main purposes in mind: firstly to celebrate the art of tattoo, a medium I have been fascinated with for the last 20 years, and secondly to give you the information that enables you to get inked wisely and well. I hope that this book is an inspirational guide to the personal adventure you will embark upon if you decide to get a tattoo.

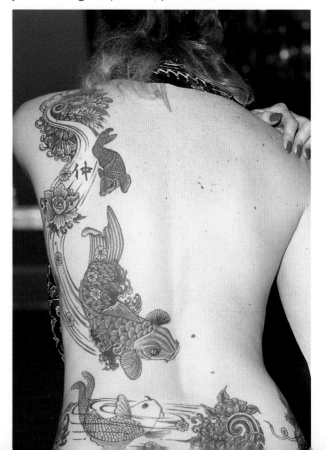

parlor

Getting a tattoo is the only permanent commitment that many of us will ever make. Once you have it you will never be able to ignore it, avoid it, divorce it, abandon it, or simply go out for the night without it. Anyone who thinks - "but I can always get it removed" - is definitely not ready to get a tattoo.

We live in a disposable society and although there is now a wide range of fake tattoos available (see Fabulous Fakes chapter), the real thing remains decidedly permanent. That's what makes them scary, and that's what makes them powerful. Making an irrevocable choice is good for the soul.

If you put energy and thought into choosing your tattoo design, it can become much more than just a piece of permanent jewelry. Properly chosen tattoos can, I believe, even confer blessings on you. Ask yourself: "What am I willing to commit to forever?" "What do I aspire to?" "What gives me strength?" Thinking about the answers to these questions can help you choose the image or images that will compose a very personal tattoo. You'll also learn something about yourself in the process.

You may want a custom tattoo, something created by the tattooist just for you, or you may find just the image you want displayed in the designs hanging on your tattooist's studio wall. Tattooists often make slight alterations to these flash designs anyway, so each customer can have a unique piece.

When it comes to tattooing, your imagination is your only limitation. A word of caution, however; although any image can be tattooed, some translate more successfully into the medium than others. In general, a big, bold image will look better on your skin than an overly detailed small piece, so if your artist urges you to go bigger with a design, listen to him. American tattooist Walt Dailey summed up the 'bigger is better' issue by saying, "A beautiful, big, fierce bear head design just looks like an angry hamster's face when you shrink it down."

15

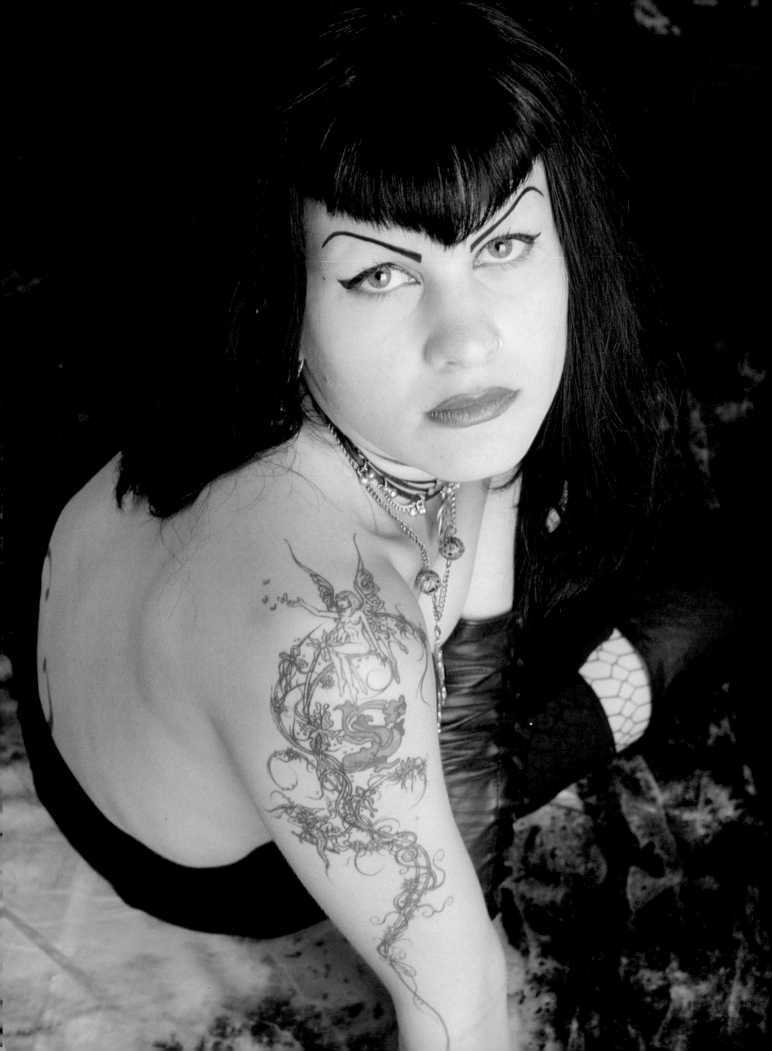

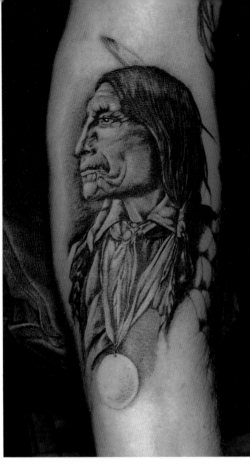

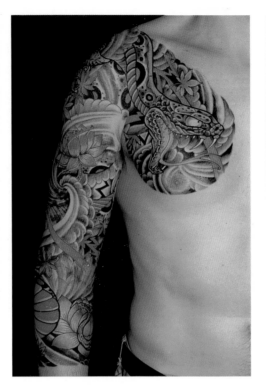

There are many different styles of tattooing. These are a few of the most popular:

Black and Gray Work: As it sounds; the tattoo is inked using only tones of black and gray.

Traditional: These pieces have bold black outlines, strong black shading, and bright colors.

Fineline: Work that is often highly detailed, using delicate outline.

Tribal: Bold, black, silhouette-style designs.

Realistic: Photographic quality work, usually portraits or nature scenes.

Custom: Original work designed just for you

Oriental: A style of tattooing that is more concerned with approach than subject matter. It utilizes the entire body as a canvas, rather than the western approach of adding a tattoo here and there as the mood takes you. The oriental style usually incorporates swirling patterns and figures from eastern mythology into the designs.

Do try to be practical when choosing a tattoo design. Getting the name of your current love etched onto your arm is a sure route to a cover-up. It is also a good idea to avoid the name of

A fine example of modern tattooing (page 16). Black and gray work by Brian Everett; oriental-style tattoos by Ed Hardy; tribal work by Sting (from left, above).

> **"GETTING THE NAME OF YOUR CURRENT LOVE ETCHED ONTO YOUR ARM IS A SURE ROUTE TO A COVER-UP."**

your favorite band, as the music that turns you on now, may not have quite the same effect on you when you're 40. Your infatuations will often fade much quicker than tattoos do. Pick something that's a little open ended. On the other hand, some of the best tattoo collections I've seen have been almost like a personal scrapbook of the wearer's life. Perhaps they aren't dedicated deadheads anymore but that 'Keep On Trucking' tattoo is a nostalgic reminder of a wonderful period in their life.

Here's a true story from which you can draw whatever moral you want. Despite all my warnings to others that they should never, ever get a name inked on them, I had my fiancé's name tattooed on my shoulder blade.

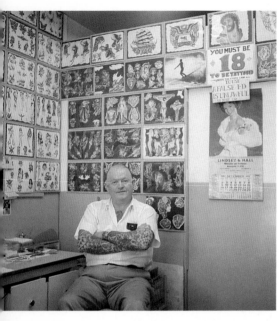

Although I was terrified for about a week after I got the tattoo, especially during our first post-tattoo quarrel, I have never regretted getting the piece. Adding a permanent symbol to my body of what I hope will be a friendship that will last forever was important to me and, besides, sometimes you just have to follow your heart.

FINDING YOUR TATTOO ARTIST
Many of today's tattoo artists have had formal art training and have also served a rigorous apprenticeship with another tattooist to learn the technical aspects of the medium. However, lurking in the shadows is the dreaded scratcher. The scratcher is an untrained tattooist who, for whatever reason, has decided that he has a great artistic gift to share with the world. The scratcher may work out of a studio, but often works from his home, the back room of a bar, or even your basement, if he can persuade you to let him set up shop there. He rarely bothers about sterilizing his instruments, or changing his needles between customers. He's often had no training in tattooing, having purchased equipment through the mail. He may spread disease, and certainly scars people for life. Beware the scratcher.

Somewhere in between the dark world of the scratcher and the brightly lit, sanitary studio of the professional tattoo artist is a shadowy world, populated by tattooists who have managed to scrape up enough money to establish themselves in a shop, and are working according to sterile procedure. Yet the tattoos they apply are badly executed, the outlines run from thick to thin, the colors are badly chosen and splotchy, and the actual artwork - well, suffice to say that perspective, proportion, and well thought-out compositions are not considerations in these shops.

The first decision that you must make, after the big one of actually deciding to get a tattoo, is that you will not settle for anything less than wonderful work. Banal, boring imagery, uninspired colors, and badly drawn designs have no place in modern tattooing.

*O*ld school meets new. A traditional tattoo parlor with classic flash designs hanging on the walls (top left). The crew from Sunset Strip (bottom right).

If you opt to have a tattoo, you owe it to yourself to choose a professional who is capable of rendering a beautiful work of art on your skin. You are also responsible for choosing a design that will bring you joy and make you proud for the rest of your life. Tattoos are created by placing colored pigments in-between the permanent base layer of your skin and the constantly changing top layer. The pigment becomes bonded to the skin cells and is visible through the translucent outer layer of your skin. So applying a tattoo properly takes much more than just the ability to draw pretty pictures. A professional tattooist is an artist, a technician and a craftsperson.

If the ink is placed too deeply into your skin, your body fluids will cause it to 'blow up' (spread and lose definition). If it's not in the skin deeply enough the colors will 'fall out' (fade or actually disappear) just a few months after you get the tattoo. (Don't confuse color falling out with the healing process of a new tattoo. It's normal to

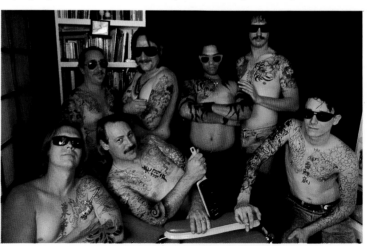

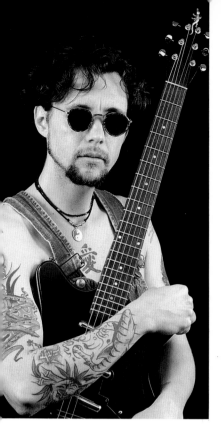

Nowadays, when choosing a tattoo design, your imagination is your only limitation. Here are a few examples of the many different styles on offer.

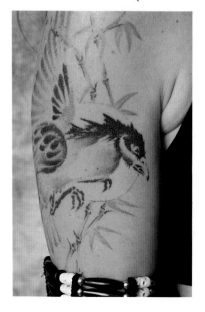

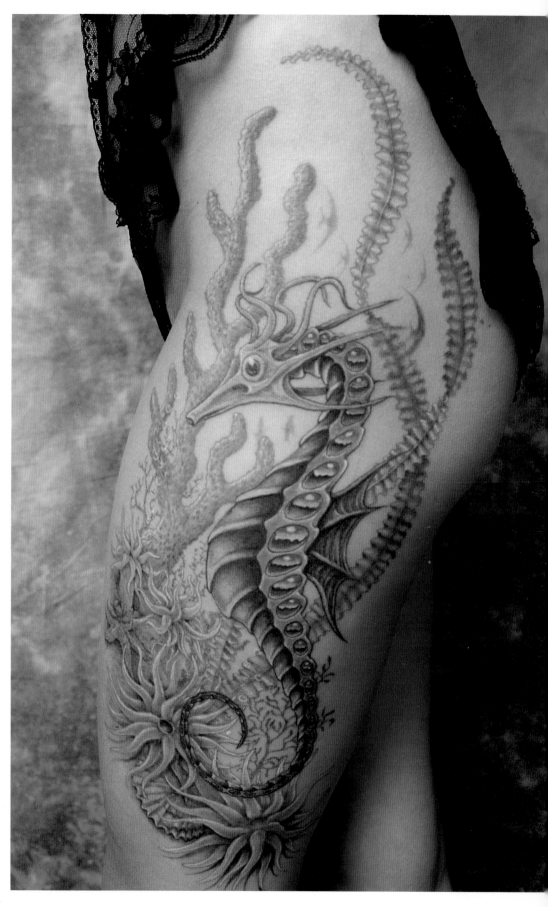

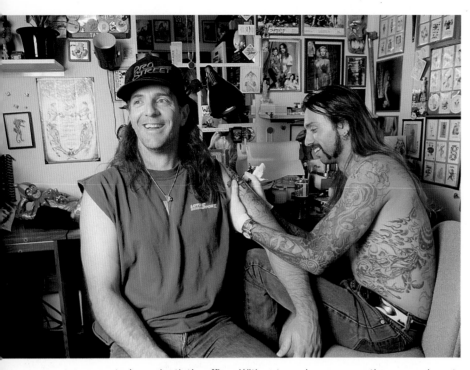

have small pieces of skin flaking off during the healing process, much as skin peels after being sunburned.)

So, obviously selecting the artist who is going to apply your tattoo is one of the most important decisions you'll ever make. Once you get a tattoo you'll never have unmarked skin in that area ever again. Hopefully you'll have enough healthy self-esteem to think long and hard before putting your precious skin into someone else's hands.

TATTOO YOU?
Having chosen a tattoo artist you should check that the tattoo studio is as clean as your doctor's or dentist's office. With extremely rare exceptions, you do not want to get tattooed in someone's kitchen, a bar, or in the middle of a field at a biker's meet. Sterile conditions can be met at outdoor rallies, such as in self-contained mobile tattoo studios, but not if the tattooist is working in a tent and has positioned himself, for example, close to the drag race track. Use your common sense, and if sterile conditions cannot be maintained in your artist's place of work, go somewhere else.

Everything that is used to apply your tattoo should be sterilized or disposable (and if it's disposable it should be disposed of after use). For example, your artist should not be dipping his needle into a big bottle of ink, he should have poured enough ink to complete the work at hand into small disposable ink containers, which will be used only for you. Vaseline and ointments should be taken from their containers with disposable sterile spreaders, not a swipe of the tattooist's fingers. Your tattooist should always wear sterile, disposable gloves. New sterile needles should be used for every tattoo.

All non-disposable equipment should be sterilized after each use with an autoclave. Ultrasonic cleaning does not sterilize equipment. It

> *"TATTOOED PEOPLE ARE ALWAYS HAPPY TO TALK ABOUT THEIR TATTOOS, IF THE PERSON WHO IS ASKING HAS A GOOD ATTITUDE AND A SINCERE INTEREST IN THE ART"*

should only be used as a method of cleaning the equipment before it's placed into the autoclave.

Having found a tattooist who works clean, you now want to see actual examples of his or her work. Photo albums will most likely be provided in the studio for you to browse through. The more cautious or paranoid among us will dwell on the fact that photos can be stolen or bought, and will want to see examples of the artist's work in the flesh. A way to accomplish this, without demanding an artist produces live clients, is to start off by attending a tattoo convention and simply ask owners of wonderful tattoos who did their work. Tattooed people are always happy to talk about their tattoos, if the person who is asking has a good attitude and a sincere interest in the art,

and will be glad to recommend artists that they are satisfied with. Don't be shy, even if you don't have any tattoos yet. You'll be respected for taking tattooing so seriously.

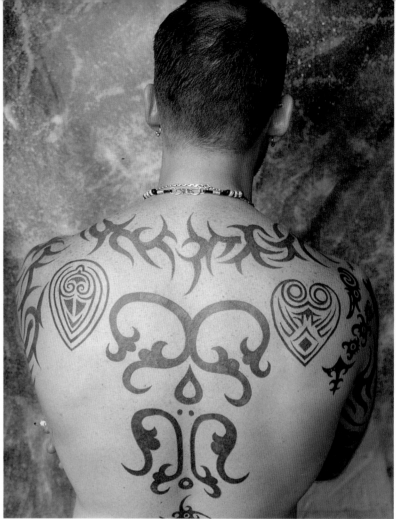

Also take into consideration the type of tattoo you want. Artists have their specialties, specific styles of tattooing that they excel at and love to do. Some artists love to work in tones of black and gray; others have a wonderful sense of color. Yes, a good tattooist can usually apply any style of tattoo you might desire and do a more than adequate job of it. Doing some research beforehand, however, can help you discover who originated the style you're interested in, or who is doing the best work in that particular style.

𝒩ick Cartwright is a multi-talented second generation tattooist - his father, Charlie Cartwright, was instrumental in introducing black and gray work to the tattoo world (page 20). Bold tribal designs gain in popularity every year (right).

Tattooists have an expression: "You get the tattoo you deserve." That translates to mean that attitude counts. Terrific tattoos are born when both artist and client are enthusiastic about the piece. You don't have to be best friends with your artist but you should both treat each other with respect. You have a right to have your important questions answered, and not to feel pressured into settling for a piece that's not quite right for you. On the other hand, remember your artist is a business person and cannot devote hours to discussing a proposed piece with you. Most artists are happy to work with the client, if they know the client is serious about getting work. Once you've picked your artist and design though, and you're sitting in the chair getting tattooed, try to resist the urge to be an art director. If you've made your wishes clear, and you should have, quizzing the artist about technical aspects of the tattoo process will only irritate him.

DOES IT HURT?
Last year I was at a party with a few friends and a bunch of people I didn't know. During the evening, one large, burly man lifted the sleeve of his T-shirt and exposed a fairly new, and rather unimpressive, tattoo. He then continued to regale his audience with a terrifying account of how agonizing the process was of getting this little blip on his arm. One of my friends, a born troublemaker if there ever was one, couldn't resist lifting my sleeve, showing my upper arm - which is completely tattooed - and saying, "Gee, Michelle said it didn't hurt at all."

The point of this story is not what a brave person I am (my pain threshold is normal, and getting that tattoo on my arm really didn't hurt that much) nor what a sissy the other person was. It is a caution to you not to believe what others may have to say about their tattoo experiences. By and large, getting tattooed is mostly just plain

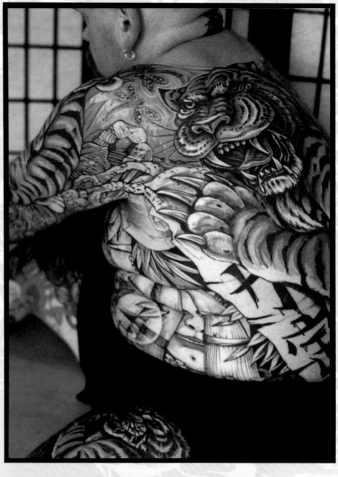

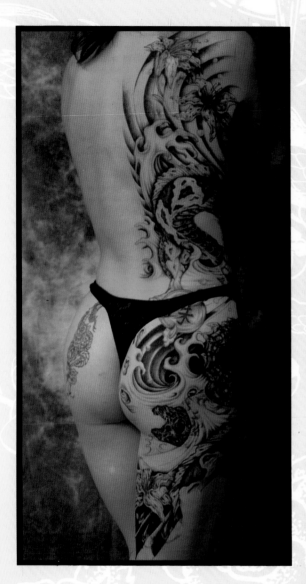

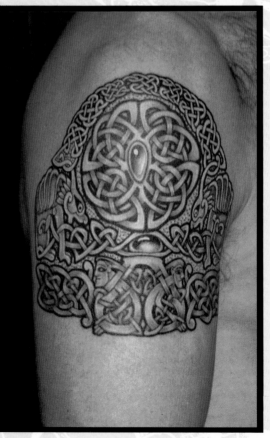

*B*lack and gray work by Bill Loika; back piece by Suzanne Fauser; Celtic design by Micki Sharp (clockwise from left). Work on punk couple by Andrea (page 23).

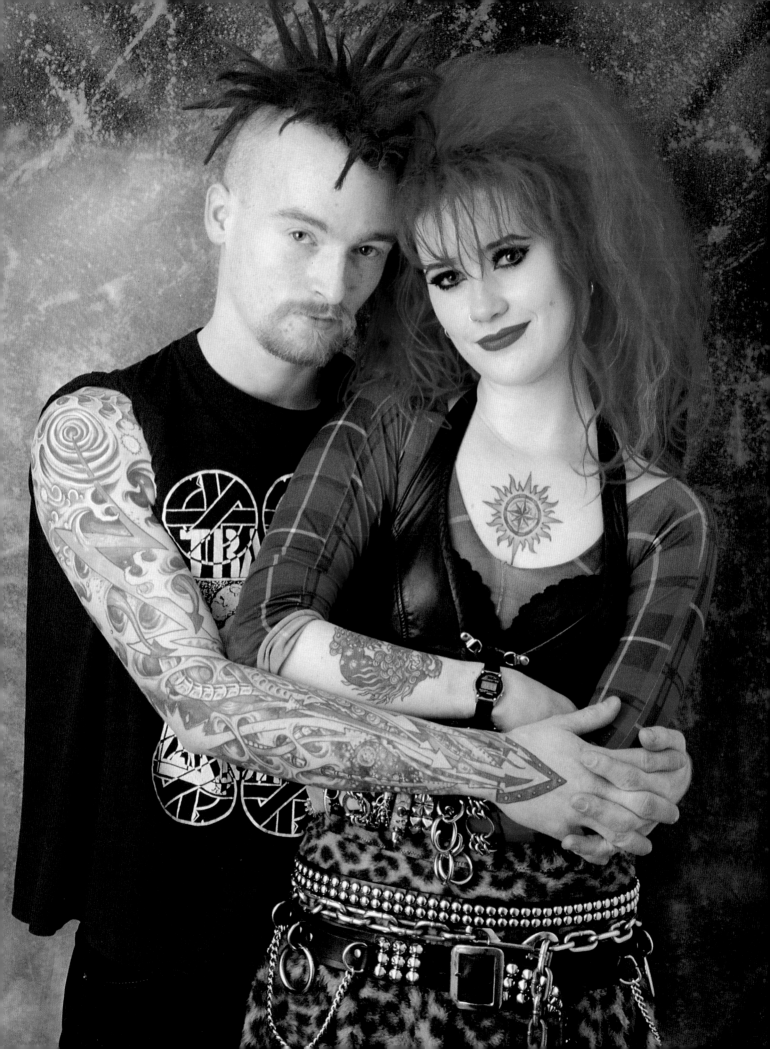

annoying, rather than out-and-out painful. There are areas that hurt more than others, and I wouldn't suggest getting a first tattoo on your ankle, rib cage or spine. Areas located close to bones hurt more. Well-padded bits hurt much less. To feel the difference, pinch your upper arm between your fingernails, and then pinch the top of your hand. Actually, I've found this pinch test to be a fairly good indicator of the sensitivity factor of any area that I have been thinking about having tattooed.

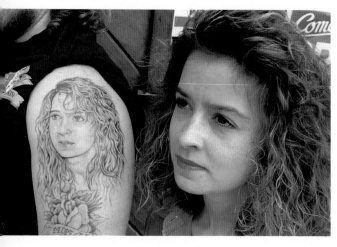

I certainly would never have gone back (several times) to get more tattoos if the process had been horribly painful. Whatever minor irritation that I experienced in being tattooed has been more than adequately compensated for since by the joy and pride that my tattoos bring to my everyday life.

KEEPING YOUR TATTOO
Once it's on your body it's your responsibility. Think of your brand new tattoo as a pet that you have just brought home. You have to feed it (with healing ointments), water it (keep it clean) and walk it (expose it to air). Unlike a puppy, though, you should avoid scratching it, however hard it begs!

Shortly after you get your new tattoo you'll notice the skin in the area of your latest acquisition will be a little bit irritated and sensitive, similar to how it feels when you have spent a few hours out in hot sun. Emotionally too, you will be feeling very tense and charged up - the direct result of the endorphins which your body releases in response to any different and stimulating experience.

> "*THERE ARE AREAS THAT HURT MORE THAN OTHERS, AND I WOULDN'T SUGGEST GETTING A FIRST TATTOO ON YOUR ANKLE, RIB CAGE OR SPINE.*"

Once you have got your new tattoo home, leave the bandage on for exactly the amount of time specified by your tattooist. Resist the temptation to look at it, as you've got the rest of your life to do that!

Anytime from four to ten hours after you get tattooed, you'll be able to take off the bandage. If this happens to coincide with your bedtime, or is close to it, leave the bandage on overnight. This will give your tattoo, not to mention your sheets, some additional protection.

When the time comes, take the bandage off gently. If it sticks, use only the amount of warm water that it takes to unstick it. Then using your hand, not a washcloth, and some gentle unscented soap, gently rinse the tattoo clean of old ointment and all the other yucky crusty stuff that might be there. Gently pat dry and lightly cover the tattoo with a small amount of healing ointment (I use one with a mild antibiotic, such as they sell in drugstores for healing cuts). You

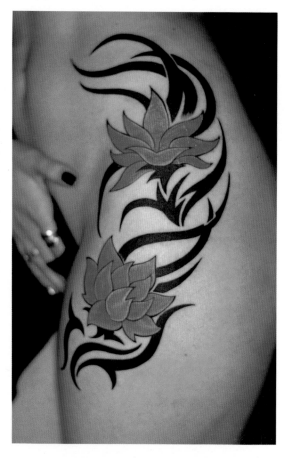

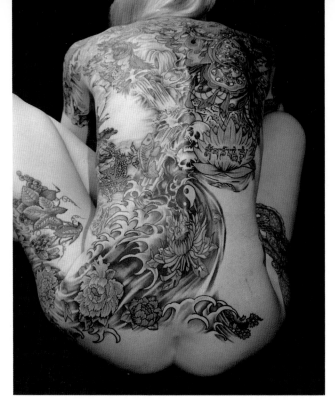

don't want to smother the tattoo with the ointment; use just enough to keep it moist. During the day, reapply the ointment when the tattoo starts feeling dry and tight. Wash it again in the evening. After the first week I switch to using a non-fragranced lotion for dry skin instead of the healing ointment, and expose the tattoo to the air as much as possible to speed healing. I also take my vitamins: extra B complex and zinc seem to help my body heal faster. The tattoo may develop a light scab, and could also peel slightly. It will itch, and you must not scratch it or pick at any scabs that might form. Keep your hands (and anybody else's) off it, except to wash it and apply the ointment. It will heal in about ten days to two weeks.

Realistic portrait work by Elio of San Francisco; an abstract tribal design on upper thigh (page 24). Back piece by Bill Loika (above). Tattoos can go anywhere - bird design on foot (below).

Do not soak your new tattoo. You can shower but keep it out of the direct spray of water. Before I get into the shower, I cover my tattoo with a slightly heavier application of ointment than usual. Don't swim for at least a couple of weeks, and don't sunbathe. You have to let your tattoo heal and settle into your skin with as little trauma as possible. I also make a point of wearing old, soft clothes over the new tattoo, garments that have been washed often enough to have the excess dye removed. A fresh tattoo is an open wound - treat with care and common sense.

GETTING RID OF YOUR TATTOO
If you've got a horrible design inscribed on your skin, or if the person whose name is in that banner on your arm just ran off with your best friend, it could be time to consider your tattoo removal options.

If you like being tattooed but just don't like the particular tattoo or tattoos that you currently have, consider getting a cover-up. Years ago, artists had stock designs that they used to cover offending tattoos. These pieces usually had heavy fields of black, such as black panthers and black clouds with lightning. Peacocks were another favorite, as you could hide a multitude of sins in those heavily shaded tail feathers.

Nowadays we don't believe that the only way to cover a tattoo is with a large dark mass. But you need a skilled artist for a cover-up job, unless you relish the idea of eventually getting a cover-up over your cover-up. I know someone who has had four cover-ups, one right on top of the other, and he's still not happy with the piece! You will need a custom piece because it will have to be designed to fit over and obliterate the existing one. Cover-up work is demanding and exacting, so you will also pay more for a cover-up piece than you would for a similar-sized tattoo applied on virgin skin.

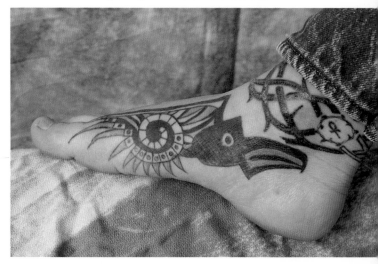

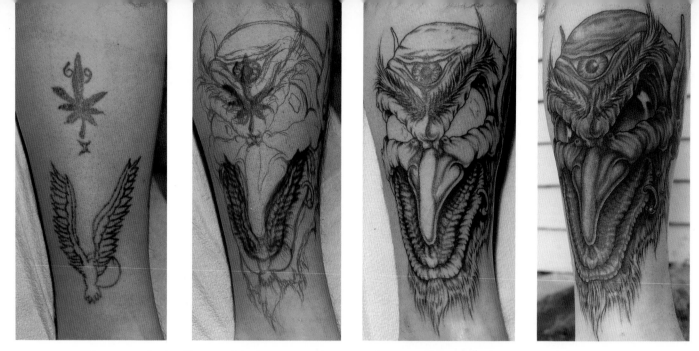

Choose somebody with a good design sense, who can work out an image that will hide the old tattoo and still give you a beautiful new tattoo to be proud of. Your artist may ask you to come back after the new piece is healed so he can go over it again and intensify the color.

Reworking a tattoo is another repair method. This means the artist doesn't cover the old tattoo but just works with it to enhance it. Perhaps you went to a scratcher and now the color in your floral piece is faded, or the outline on your arm band is jagged. If you're basically happy with the piece you might just need some corrective work. The best example of reworking a tattoo that I've ever seen was done on a portrait piece on my friend's arm. The tattoo in question was a portrait of his wife, who ended up leaving him in a particularly nasty way. He didn't have the tattoo covered up, no, he had it subtly reworked just enough to turn the lovely portrait of his wife into a screaming, crazed demon who still had, very recognizably, his wife's face.

Any reputable tattooist will also fix any skips in color or the outline that may be discovered shortly after the piece is healed. But if you picked and scratched at it during the healing process and literally stripped the color out of your skin, don't expect the tattooist to perform this service for free. If you were conscientious about your aftercare routine and still noticed a problem, go back and ask the tattooist about it.

> *"HE HAD IT SUBTLY REWORKED ... TO TURN THE LOVELY PORTRAIT OF HIS WIFE INTO A SCREAMING, CRAZED DEMON"*

If you're really unhappy about being tattooed, or have one of the rare pieces that can't be covered up, you can investigate laser removal. Its pros are that it can remove almost any tattoo, with very few incidences of scarring or hyper-pigmentation, and is relatively painless: it's usually compared to having a rubber band snapped against your skin. Unfortunately, it's very expensive. Dermabrasion has also been used for tattoo removal (a method described as similar to having your tattoo removed with sandpaper), as have chemical peels and acids. My feeling is that treatment with a laser is the way to go. Check with a plastic surgeon for a more in-depth discussion of your options and some recommendations about who should do the procedure. If you happen to come up against a doctor who has a lousy attitude about tattoos, then go somewhere else.

Of course, if you remember to think before you ink, you'll never have to worry about the expense and pain of getting rid of an unwanted tattoo!

tattoos

We live in a society that is absolutely star struck. One reason for this sorry situation could be the lamentable lack of true heroes to worship. There is, of course, Mother Theresa, and personally I believe that she, as well as the many 'ordinary' people caring for others who are desperately ill, should be regarded as the real heroes of our time.

I'm much more impressed by folks who manage to live gracefully when life has hit them with a terrible blow than I am by somebody who has merely been blessed with a good singing voice or an arresting facial structure.

We used to look up to politicians, but in an unstable and fragile world that's neither possible nor practical. However, many people need role models, and so turn to the latest movie, television or music stars to give them guidance and inspiration in their own lives. It would be good to think that someday we'll get away from our compulsion to seek approval. After all, a life imitated is a life only half lived.

GET AHEAD, GET A TAT
The list of tattooed celebrities is now quite extensive and the reason we tend to know about them is that they're usually thrusting their tattoos into the lens of every camera that's focused upon them.

Do you detect a note of hostility in my voice? Well, maybe just a little, as any craze inevitably attracts those who have not properly thought it through. Of course, tattooing is one trend that, by its very nature, is going to last. The fashion magazines occasionally try to say tattooing is no longer 'in' anymore, but that's not much use to anyone whose tattoos won't scrub off. The dedicated followers of fashion will, therefore, just have to keep their interest in tattoos alive or spend their time constantly rearranging their clothing. Tattoos are also very addictive: the

likelihood of beating the temptation to get another one is just another of the hazards that has to be faced.

However, in another way, tattooed celebrities have been a godsend for tattooists. Now, every trendy hippie and rock star 'wannabe' thinks they need a tattoo to be really cool. Getting tattooed is no longer just for bikers, sailors, tramps, prisoners and other 'marginal' members of society. The sudden interest celebrities have developed in tattooing has helped to keep a great number of tattooists in business, as well as increased interest in, and acceptance of, the art.

Having said that, I don't think that anyone should get tattooed unless, quite simply, they need

> ## "*NOW EVERY TRENDY HIPPIE AND ROCK STAR 'WANNABE' THINKS THEY NEED A TATTOO*"

to. "Wait until the tattoo gods speak to you before you get a tattoo," is a saying that gets heard a lot in the tattoo community. Like most phrases that get repeated over and over, it contains more than a grain of truth. Tattoos are not a style statement; they are a personal commitment. Although I

Just like regular folks, some celebrities have far more tasteful tattoos than others. I'll leave it to you to decide which category Jody Watley's cherub falls into (below).

spent most of my teenage years in one tattoo shop or another I didn't actually take the plunge and get inked until I reached a relatively ripe old age. By then I was sure that my desire to sport ink wasn't coming from peer pressure and I also felt I knew myself well enough to be really comfortable with making a permanent alteration to my body. I'm not saying everyone should wait until the bloom of youth has faded, but I do believe that most of the tattoos that I would have chosen at the age of 18 would now be hidden by cover-ups.

CELEBRITIES REVEAL ALL

Celebrities started rushing to get tattooed about ten years ago. Of course, there were always the brave few who sailed against the wind and got their skin art before it became stylish. Sean Connery is one; his two tattoos, 'Wales Forever' and 'Mum and Dad', are as much a part of him as his sexy accent. I enjoyed watching him play a medieval monk in *The Name Of The Rose* to catch a glimpse of those tattoos every so often. Hardly the most fitting accessory for a Dark Ages ascetic, but Sean carried the whole thing off with his customary aplomb.

Some of today's celebrities would probably never have dared to get a tat before the current rage for them. Others are born skin art fanatics. It seems quite likely that Roseanne and Tom Arnold, for example, would have ambled into a tattoo shop eventually. Cher is another who could well have decided to get one herself, although I've never been quite sure if she sets trends, or merely catches onto them quicker than the rest of us. However, Jody Watley, along with most of those superstar models with their easily concealed, tiny tattoos, was more obviously jumping on the bandwagon.

The tattoo designs that most actresses and models tend to opt for are small, safe and strategically placed to be almost invisible. Jody Watley has a cherub blowing a horn with 'Love' inscribed under its precious little feet. Drew Barrymore has a cross on her ankle. Supermodel Christy Turlington has a discreet red rose on her ankle. Sally Kirkland has a dumb little star over her breast. Melanie Griffith has a couple of boring little blips.

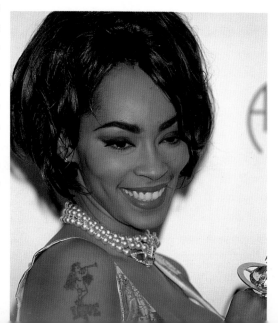

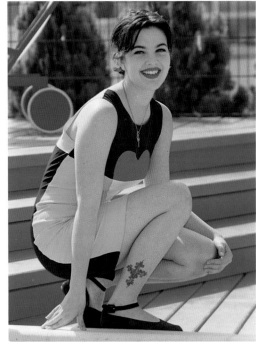

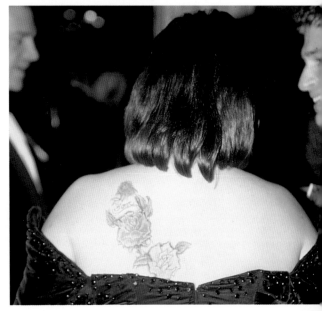

*C*her, Drew

Barrymore and

Roseanne Arnold enjoy

showing off their tattoos.

ANOTHER ROCK 'N' ROLL REVIVAL?

On the whole, rock 'n' roll stars have more interesting tattoos. Henry Rollins has got a great collection of well-conceived and interesting tats. Since his days with Black Flag in the early Eighties, Rollins has been getting his body covered with personalized, serious tattoo art; symbols that speak strongly of his life and philosophy. His first tattoo was the Black Flag emblem, four solid black bars on his biceps. He'd added two more Black Flag logos before the band went their separate ways.

The best of the rock star collections: Henry Rollins' work by Rick Spellman (right); Ron Young's work by Gil Montie (below) and the Red Hot Chili Peppers - Kiedis' back piece by Hanky Panky (page 31).

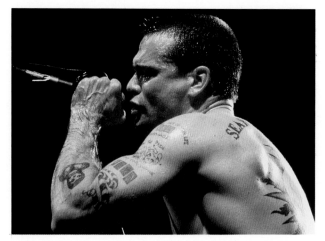

Rollins also has a fondness for mixing words and imagery - 'Life is Pain, I Want To Be Insane' wraps around a piece depicting two skulls; 'More Than Soul, Some Kind Of Love, Some Kind Of Hate' circles a bulging heart that has 'Raw Power' inscribed on it. A bunch of flowers on his upper arm with the word 'Poison' inked beneath was done to express his admiration for the bands Einsturzende Neubauten and the Misfits. The best known of Rollins' tattoos is a back-piece of a blazing sun, above which huge, black, no-nonsense letters declare 'Search And Destroy'. Rollins explains that this sums up his philosophy about life: because it is so short you should live it to the maximum. Although he appreciates the diversity of work currently coming out of the tattoo studios, these days Rollins' main interest is in tribal work. He continues to add pieces to his collection, filling in the empty spaces on his shins with bold, black, silhouette-style tribal designs. All his tats are done by Rick Spellman who works in Los Angeles.

Anthony Kiedis from the Red Hot Chili Peppers has one of the best backpiece tattoos that I've ever seen. It's a beautiful design based on the art of the Northwest Coast Haida Indians and was inked by Hanky Panky in Amsterdam. This artist is known for his bold work, and holds strong views about the aesthetics of tattooing. Hank does not have much faith in the longevity prospects of fineline work, unless it's done by one of the few artists

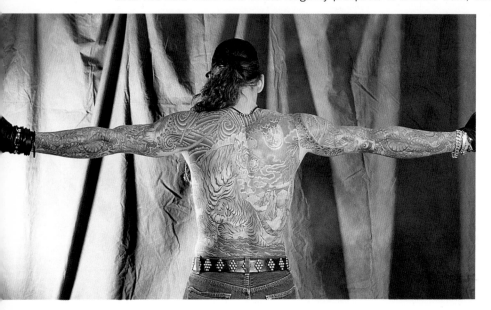

that he feels can really handle the technique. He has traveled extensively to research the traditional designs of many ancient cultures, and his tribal work has an authenticity that's hard to beat. His tattoo shop, in the heart of Amsterdam's red light district, also contains a tattoo museum that is a treasure trove of artefacts and photos tracing the history of the art.

Ron Young from Little Caesar is covered with extraordinary work, much of which was inked by Hollywood's infamous 'tattooist to the stars' Gil 'The Drill' Montie. Gil is renowned for his

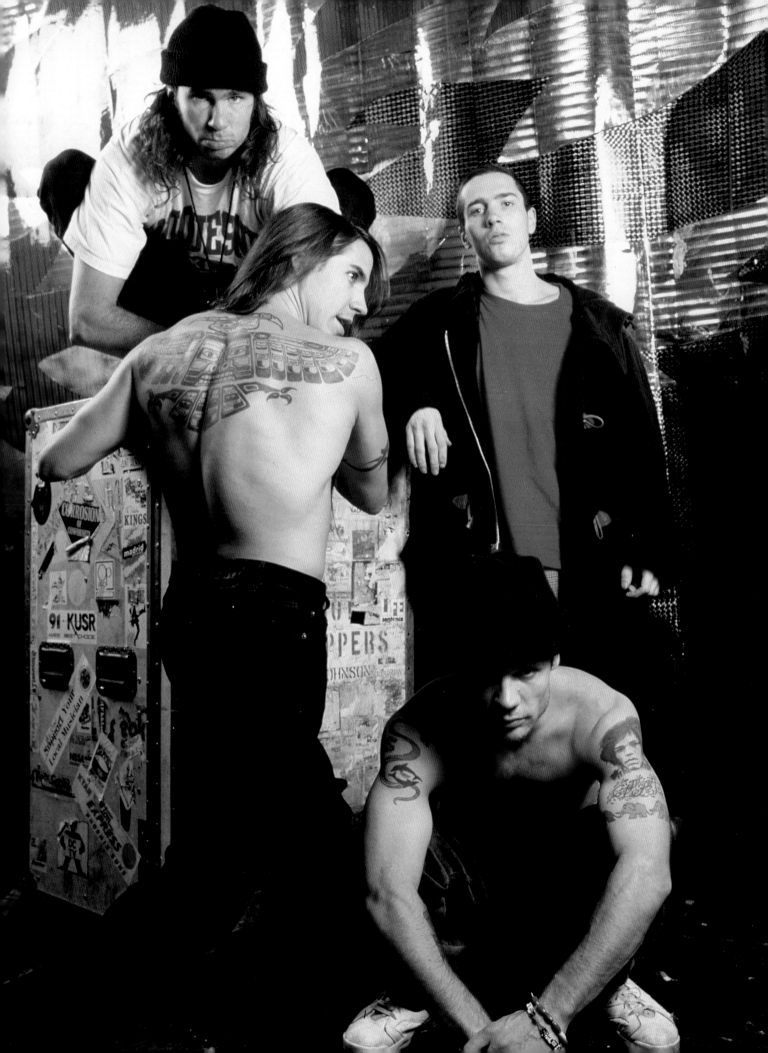

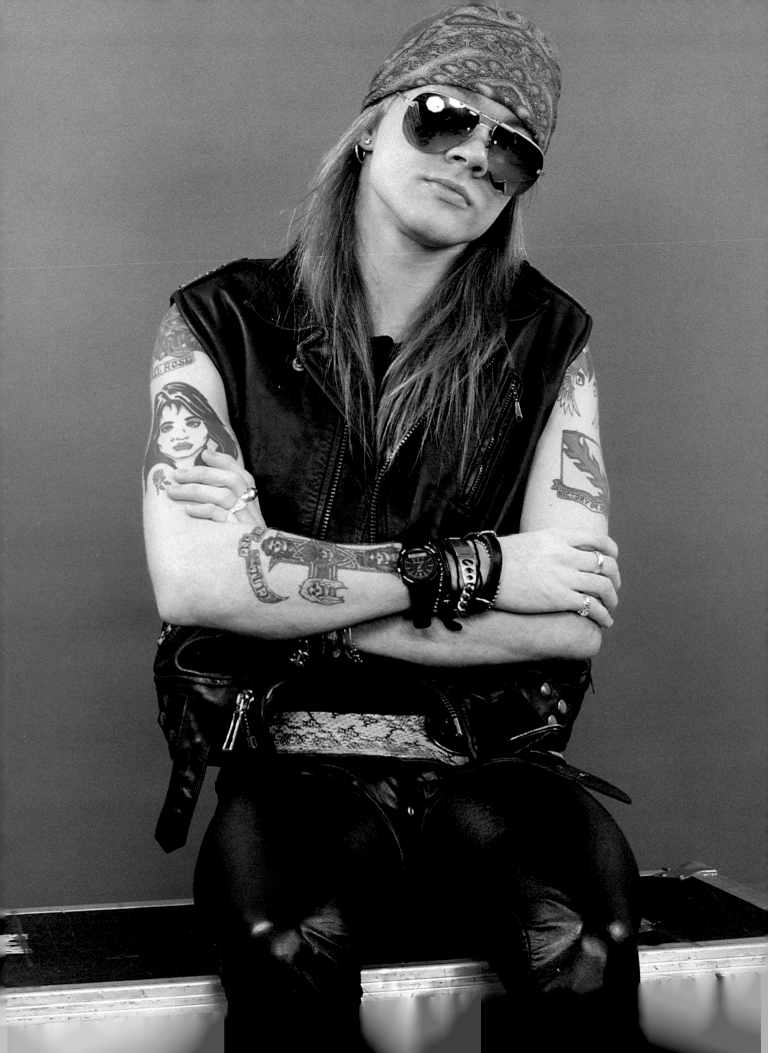

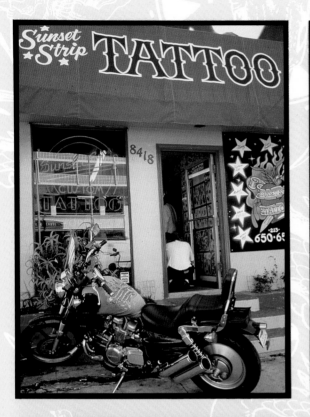

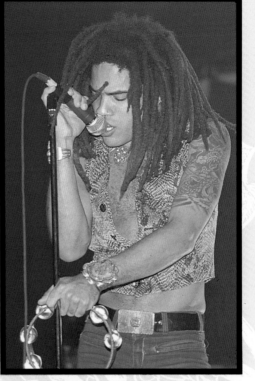

*A*xl Rose strikes a pose, he got most of his tats from Sunset Strip (page 32). Lenny Kravitz flashes a half-sleeve (left), and the Crüe show that their tat-toos are anything but motley (below).

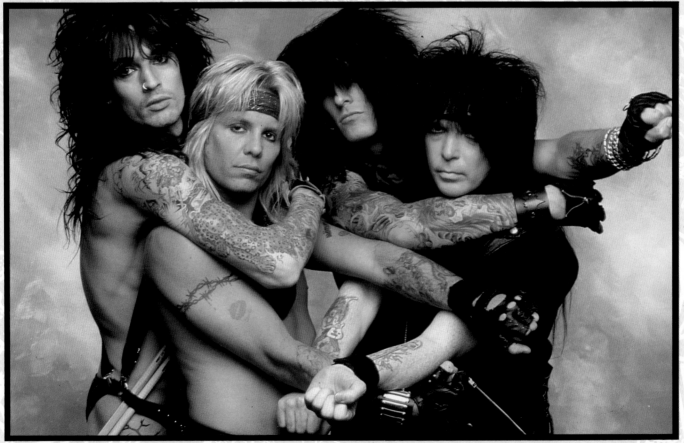

skull tattoos; usually they have big bulging eyes and the broadest grins that you're ever likely to see on a hunk of bone. Ron Young wears two of those famous Montie skulls just below his rib cage, on either side of his waist. Full

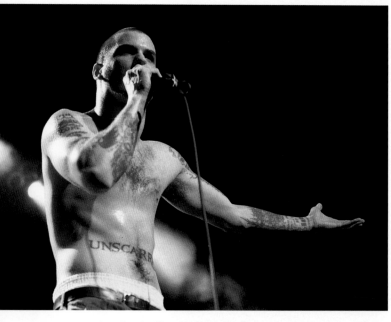

sleeves, composed of an assortment of oriental-inspired imagery, and a terrific backpiece of a tiger looking at a moonlit sky, make Ron's one of the best celebrity tattoo art collections around. The tattoos on his arm and back are tied together into a unified piece by bold black spirals that start on his upper right shoulder and continue onto the top of his back.

Another rock star who owns an interesting tattoo collection is Rob Halford, lead singer of Judas Priest. Rob's got a half sleeve that has a sorcery feel to it; the result of several years of enthusiastic collecting. Featured in the imagery is a traditional-style Hot Stuff devil with a pitchfork, some floating musical notes, a couple of skulls and some tribal motifs. An obvious and not particularly successful attempt was made to tie this assortment together by the application of swirls of water and fire around the piece. The singer also has two chest pieces of dragons in flight, and a blue lightning bolt on the side of his head. Although Rob's tattoo collection is far from being an artistic triumph, it certainly looks as if it is well loved.

Phillip Anselmo, lead singer of Pantera has an impressive tattoo collection(left). One of the many tattoos that decorate the body of rock singer, Ozzy Osbourne (page 35).

Other rock artists who have subjected themselves to the needle include Evan Seinfeild from Biohazard (who is almost completely covered with extremely cool images); Edgar Winter, one of the best blues guitarists of all time, (that pale skin of his is a wonderful backdrop for the colorful pieces he favors); and Lenny Kravitz (who was tattooed by Roy Boy of Gary, Indiana). Slash from Guns n' Roses gets much his work from the artists at Sunset Strip Tattoo in Hollywood. He's got some great stuff. Fellow band member Axl also has some great tattoos, although he refuses to discuss them.

The boys from Mötley Crüe have an eclectic approach to tattooing; drummer Tommy Lee has everything from Mighty Mouse to leopards inked onto the flesh of his arm, while ex-vocalist Vince Neil is probably going to have to invest a small fortune to cover up his Mötley Crüe insignia. Maybe he'll decide to keep it just for the memories.

" **E**X-VOCALIST VINCE NEIL IS PROBABLY GOING TO HAVE TO INVEST A SMALL FORTUNE TO COVER UP HIS MÖTLEY CRÜE INSIGNIA. *"*

The lead singer of Pantera, Phillip Anselmo, has a cool arm piece; big block letters on his right arm declare 'Body+Blood, Joy+Pain, Life+Death'. Other inscriptions include 'Unscarred' tattooed across his stomach, and 'Shattered Soul' inked around the image of a zombie-like priest. In addition, a beautifully executed black and red snake lazily winds down his lower forearm. Phillip's declared intention is to get portraits of the greatest prize fighters in history tattooed on his back. His tattooist is Randy Adams of Texas, who has also worked on Rex Brown,

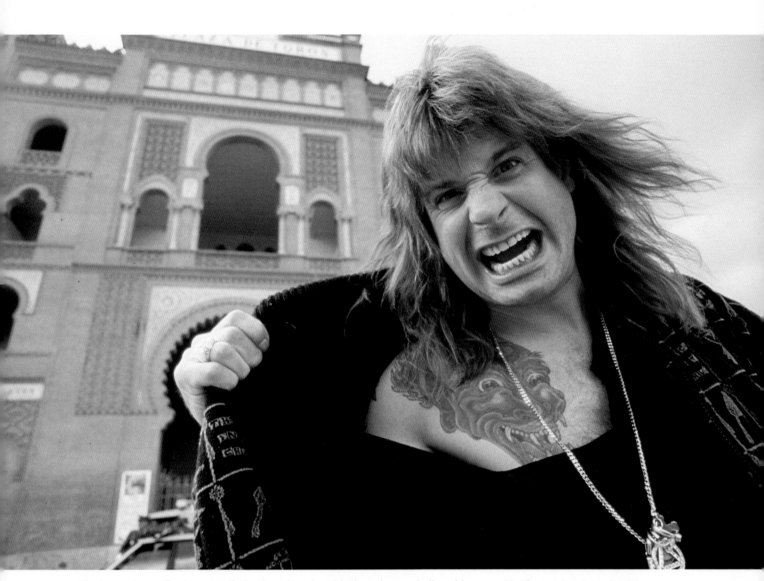

the bass player. Rex's most distinctive piece is a black and gray skull on his arm with 'Screaming Agony' written underneath. Pantera's guitarist, Diamond Darrell, has a piece commemorating the band's first record deal, which incorporates the title of their first album 'Cowboys From Hell'. Darrell's collection also includes Judas Priest and Seagram's Seven logos and a tattooed tooth surrounded by the words 'Black Tooth Grin'.

While we are dealing with rock 'n' roll history we should not forget the old bat biter himself, Ozzy Osbourne. He made the all-too-common mistake of getting his old lady's face turned into a portrait piece tattoo. Presumably it was a last-ditch effort to salvage the romance, but it was pretty pointless as she divorced him shortly after. John Cougar Mellencamp was another rock star who made the same mistake but, luckily, the right tattoo artist can cover up almost anything these days!

Do you remember the Village People? They were the guys who dressed up as a biker, sailor, construction man, cop, cowboy and Indian to perform such memorable classics as 'YMCA' and 'Macho Man'. A couple of them are into tattoos, most notably Felipe, who nowadays, as part of a Village People comeback bid, appears on stage in full Native American Indian gear, complete with an armband tattoo of feathers and beads.

Another great tattoo collection owned by a guy on the comeback trail graces the body of Brian Setzer of Stray Cats fame. Brian is a real tattoo fan who attends many conventions, where he is content to sit around, relax and talk about skin art with other fans. Brian's tats have a funky rockabilly Fifties look to them; his license plate even reads '4 Tattoo'.

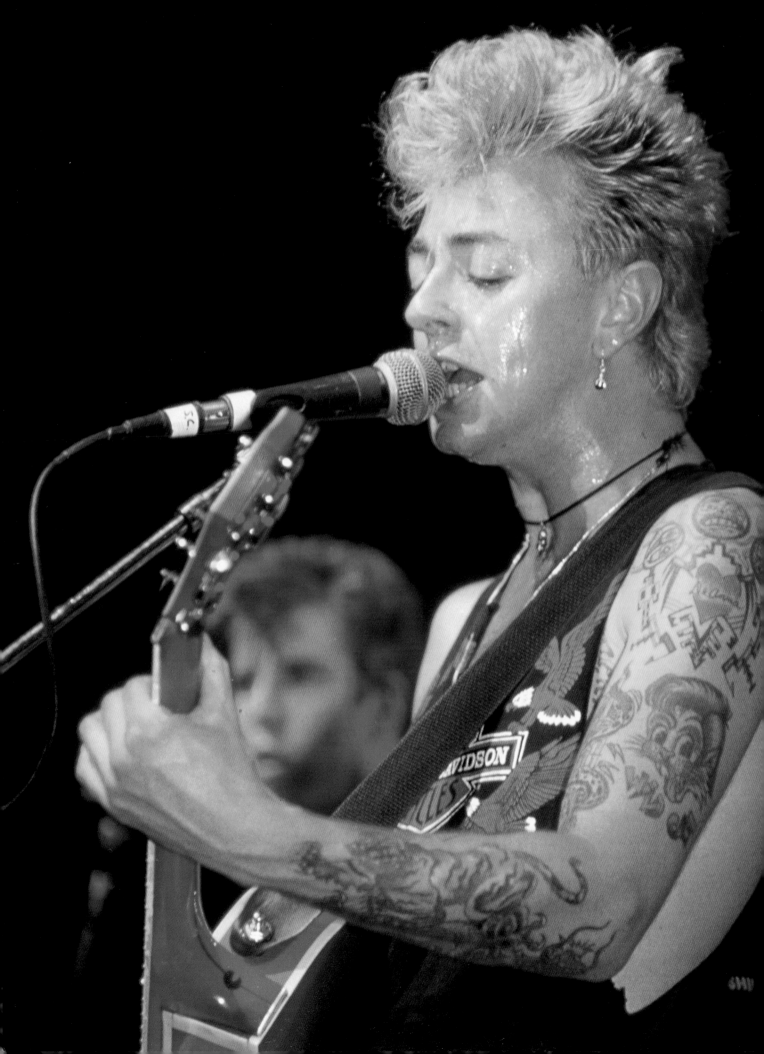

*B*rian Setzer (page 36) is a long-time tattoo fan, while Sebastian Bach (left) and Cher (below) are fairly recent converts.

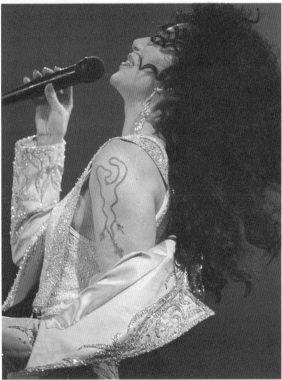

It's debatable whether one would want to call Cher a rock 'n' roll star, but she certainly has some excellent tattoo work gracing her body. When you look at her tats you can see that she has made an effort to educate herself about the art over the years; her first pieces are rather dull and uninspired but her latest one, the jeweled bracelet that Jill Jordan of Hollywood applied to her upper arm, is simply stunning.

TATTOOING THE STARS

Most tattoo artists agree that musicians are fairly easy to work on. Sometimes boys in rock 'n' roll bands relate colorful stories about how and when they got their work: "I was so drunk;" "We'd been partying all night;" "I woke up and there it was;" or "The artist spelt this word wrong" are just some of the excuses you hear. You shouldn't always believe what they say, however, especially if their bodies feature some decent tattoos. Professional tattooists don't work on drunks or druggies and they're damn good spellers.

The aforementioned Gil Montie works in Hollywood, California so he gets his fair share of rock 'n' roll musicians; they're usually to be found mixing right in with the rest of the crowd at his Tattoo Mania studio. Ron Wood has even manned the reception desk on a couple of particularly busy weekend nights. Gil has appeared in a few music videos and designed some album cover art featuring tattoos for various bands, most notably Poison. He's also responsible for Roseanne and Tom Arnold's skin art, which, if you happen to be one of the few people left in the world who hasn't already seen the pictures of the Arnold collection, includes multiple portraits of themselves (on each other, of course) as well as 'Property Of Tom Arnold' on Roseanne's butt and a very large Star of David on Tom's chest.

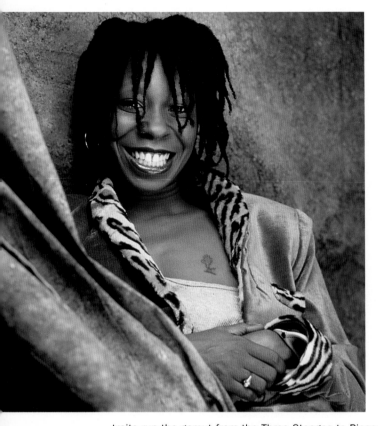

With the exception of the Arnold family, who Gil says are "real nice folks," most movie stars seem to believe their own publicity and assume they are due special attention and privileges from everyone, including their tattooists. A certain lady singer who shall remain nameless, but who has a fondness for very young men and rather loud outfits, called her Hollywood tattooist (not Gil) and demanded an immediate appointment. Well, this particular tattooist has a long waiting list for her services. The singer in question did not accept this information gracefully, assuming that her celebrity status would bump her straight to the top of the list. However, she didn't get the appointment as, on the whole, tattooists are hard to impress. The word on the tattoo grapevine was that this singer had wanted to get a rather personal area of her body tattooed to resemble a butterfly, to match an existing butterfly piece already located in the same vicinity.

Another type of celebrity tattoo trend that seems to be becoming increasingly popular is getting a portrait of your favorite star permanently inked into your skin. These portraits run the gamut from the Three Stooges to Picasso. I know a tattooist who has a massive portrait of Madonna covering his entire back. There's another guy whose body is decorated with several portraits of history's most famous mass murderers, including such notable personalities as Hitler and Stalin. One of the most stunningly beautiful backpieces I've ever seen is a portrait of the wearer surrounded by exquisite likenesses of his favorite musicians of the sixties; Joplin, Hendrix and Morrison. Yet another, covering the back of a horror movie fan, features his favorite stars in character, such as Bela Lugosi as Dracula and Lon Chaney as the Phantom.

RECOGNITION AT LAST

To me, though, the real tattoo celebrities are all the tattoo artists who crank out good work every day, as well as the artists working in other media whose art inspires some wonderful tattoos. One of these is artist Robert Williams whose oil paintings, with their bright, primary colors and wonderfully twisted imagery, have inspired and informed the popular tattoo genre of comic-based art. Graffiti artist the Pizz, who designs flash based on his hotrod, graffiti-style artwork, and painter H R Gieger, whose high-tech metal machine paintings have spawned a whole generation of bio-mechanical cover-up work, are just two more of the many 'outlaw' artists who have assisted in the art of skin decoration. These artists, along with a growing number of excellent tattoo practitioners, are the real heroes, for they have helped to give tattooing the celebrity status that it has, for so long, deserved.

> "*A CERTAIN LADY SINGER, WHO SHALL REMAIN NAMELESS, BUT WHO HAS A FONDNESS FOR VERY YOUNG MEN AND RATHER LOUD OUTFITS, CALLED HER HOLLYWOOD TATTOOIST*"

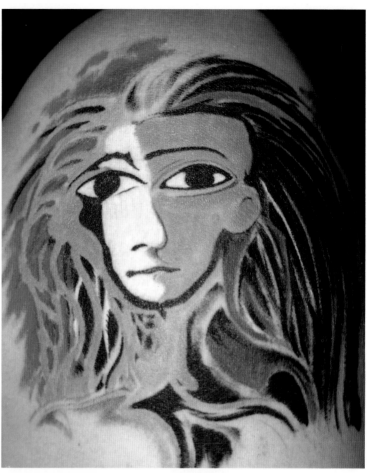

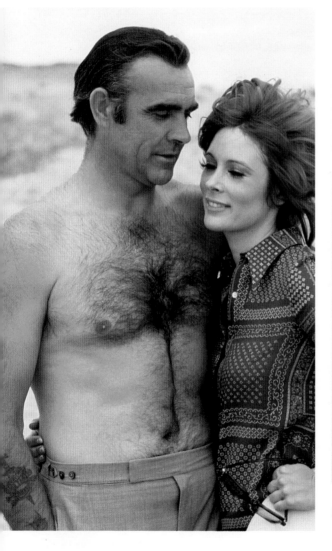

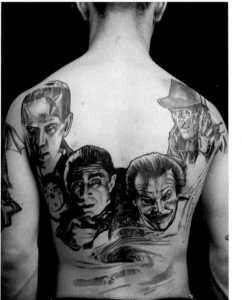

W hoopi Goldberg flashes a smile - and her tattoo (page 38). Sean Connery and Mickey Rourke display their tattooed arms (both left). Some personal passions etched onto skin (right).

fakes

Most of us who are now covered with permanent skin art first started decorating our skin in childhood with temporary tattoos. Back then these fake tattoos were pretty crude. You bought them in your local sweet shop or got them as a free prize with certain types of candy.

Inside each packet were a number of smeary paper transfers featuring that traditional pirate and sailor type of design, such as anchors, ships and hearts. To fix them to your body you had to wet the transfer under the tap (the more impatient among us simply spat on them) and press them firmly to your flesh. The whole process only took a minute to transform you into a wild, untamed being. At least until mom called you in for dinner and insisted that you washed those disgusting things off, immediately!

Many tattooists came to the realization that they were born to ink early in life through an insatiable desire to decorate their friends. Ed Hardy, who in his later years went on to revolutionize the art of tattooing, had a temporary tattoo parlor when he was ten. He applied tattoos to his playmates, using colored pencils. This was no ordinary child's game though. Ed mimicked the standard set-up of a tattoo shop as best he could, right down to the flash art he drew and hung on the walls. Many parents shrieked with horror when their kids came home from a day of playing at the Hardy household, because Ed's tattoo replicas were authentic enough to pass for the real thing. Of course, the kids didn't want them removed, and cried as a relieved mom scrubbed the offending art away. Some of the shrewder ones attempted to hide their 'tattoos', but, being crayon, the evidence would be all over their sheets and pajamas the next morning.

A **butterfly temporary tattoo design that could pass for the real thing (below).**

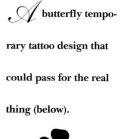

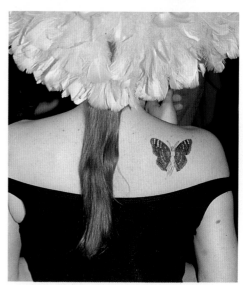

40

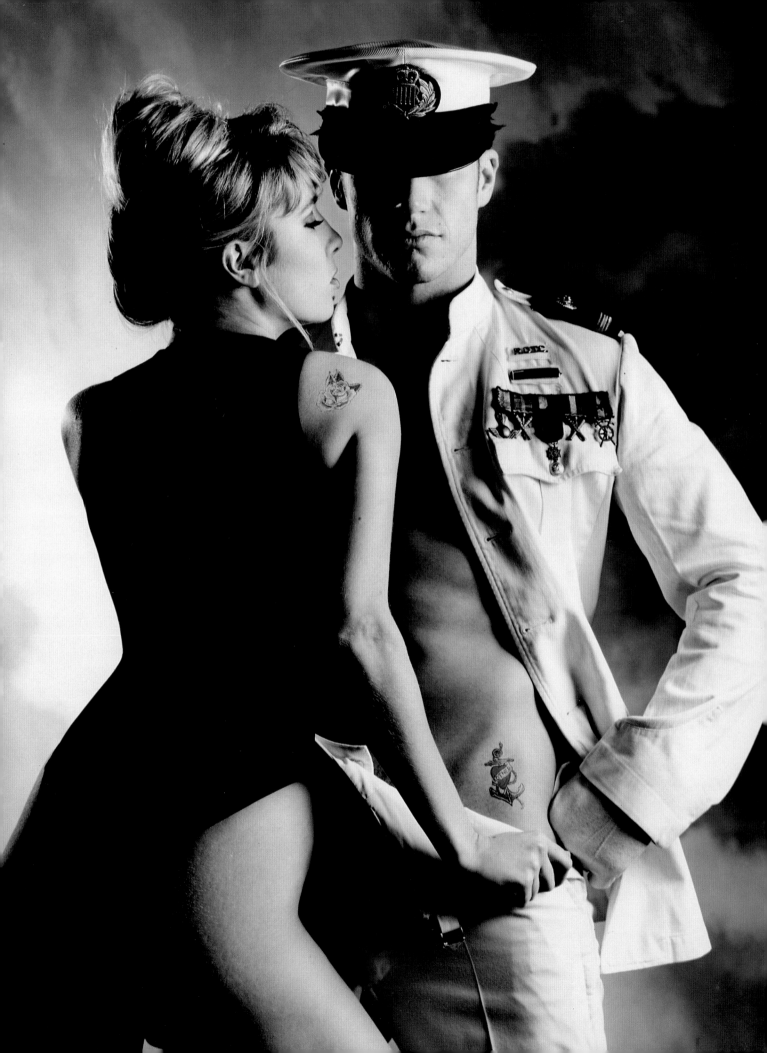

DRAWING ON THE BODY

Most kids played with temporary tattoos for a day or two and then moved on to other pursuits. However, a few of us just weren't comfortable walking around in our naked and colorless skin. We continued to spit and stick, or to doodle on our forearms with pens or magic markers, until we hit the magic age of consent and trooped off to the local tattoo shop to finally get ourselves the real thing.

My first attempts at enhancing my body with art were years before I set foot in a tattoo parlor. I asked more artistically gifted friends to draw pictures on me, and then, when I was about 12, moved on to sticking those little gummed stars onto myself, the kind that teachers glue on book reports and passing grade papers. I even got into holiday themes with these stars; such as red and green for Christmas and red, white and blue for the fourth of July. Thank goodness my star-stuck stage was shortlived!

Nail decorations were for me another early form of body modification, feeding the same urge as the application of tattoos. I became hooked after I discovered that there were women out there with air brushes who would draw pictures on my nails. I would sit patiently for a couple of hours while some exceptionally well-manicured person painstakingly applied stencils to my nails, turning them into veritable fiestas of color and form. I had tropical jungles, abstract art, Halloween witches and black cats applied to my nails, although I drew the line at sequins and sparkling stuff.

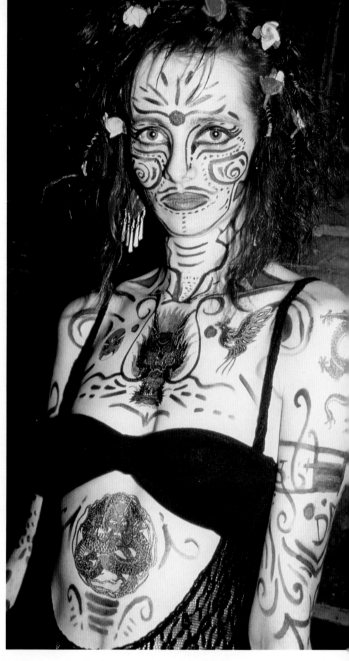

After a while, I discovered a nail lady who would, for a hefty fee, custom design your nails. My favorite design commissioned from her was of a miniature classic Harley-Davidson motorcycle, painted on each of my ten nails. It seemed all right at the time although now, looking back, I wonder what I could have been thinking of!

Another craze I can remember from my youth was for 'tan tattoos', which were obtained by cutting simple designs out of paper, or forming them out of adhesive tape, fixing them to your body, and laying out in the sun for a few hours. This, of course, was in the good old days when the ozone layer was intact and tanning was considered a reflection of a healthy lifestyle. After frying yourself to a crisp, you staggered inside to remove the paper or tape, to discover that the covered area was now several shades lighter than your newly tanned skin.

One miraculous day, several years later, I was browsing in the local hippie shop and, through the haze of

> *"**W**E CONTINUED TO SPIT AND STICK, OR TO DOODLE ON OUR FOREARMS WITH PENS OR MAGIC MARKERS"*

patchouli oil and strawberry incense smoke, spied something called 'Temporary Tattoos.' To my delight, these were not silly little sailor designs in harsh shades of blue and red that I could expect to discover in the bottom of my Cracker Jack box. Quite the opposite: these featured a number of highly decorative, intricate designs and were exactly what I had always hoped I might find. Needless to say, I bought plenty.

> ## "SHE SHOOK HER HEAD, COMPRESSED HER LIPS TIGHTLY AND SHOT A MEANINGFUL GLANCE AT MY TATTOOS, WHICH WERE PEEKING OUT FROM THE COLLAR OF MY SWEATER."

My first couple of attempts to wear temps were rather dismal. The little bits of paper had to be carefully cut out and then wet (not soaked) with warm water. Then they were placed and pressed firmly onto the skin for a moment or so. Somehow I always used too much water, or not enough, or wanted to peep before they set properly on my skin. Consequently, I usually ended up with half-formed mush instead of the particular design I was hoping to see. Once I had mastered the application procedure they looked very pleasing. Then I asked my mom to put them on me, as there were places on my body that seemed to be crying out for decoration that I couldn't reach. She got quite good at it, a talent that has since endeared her to her grandchildren.

Temporary tattoos have recently become an essential fashion accessory. The wide range of designs currently available allow you to create an outrageous look (page 42) or something a little more subtle (right).

PLAYGROUND ATTRACTION

I see the age-old desire for tattoos beginning to manifest itself in my son's fascination with the temporary tattoos that many of my tattoo artist friends generously give to him. One day he came to me and asked to go to school wearing temps on his forearms. I let him do this, and the following day he asked if he might have some packets of the transfers to hand out to his friends. We'd just been given a box from someone, so I gave him a large handful.

However, when I went to pick him up from school that afternoon, his teacher pulled me aside and said how startled and even frightened she was when the kids trotted back in from lunch recess, as suddenly they were all covered in tattoos. I told her I thought it would have been obvious that they were fakes, unless she seriously believed a very fast-working rogue tattooist had set up shop in the playground. She shook her head, compressed her lips tightly and shot a meaningful glance at my tattoos, which were peeking out from the collar of my sweater. The look was obviously intended to mean that someone like me could not be expected to understand what she'd been through that day. I should also mention that the tattooed kids looked very happy as they trooped onto the bus. No doubt we'll be seeing some of them at a tattoo convention in a decade or so.

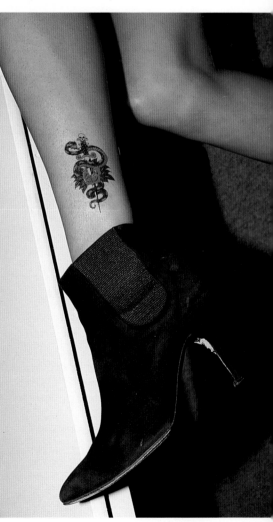

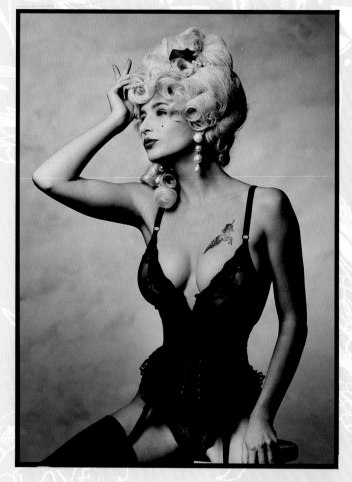

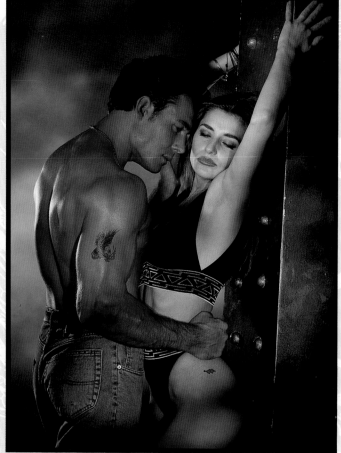

*T*attoos discreetly placed on strategic parts of the body can be used to add a touch of glamor or as part of an erotic statement - with the obvious advantage of instant removal when no longer appropriate.

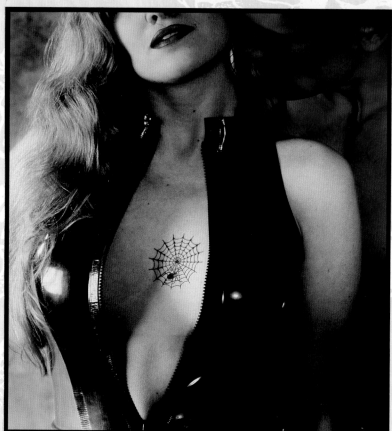

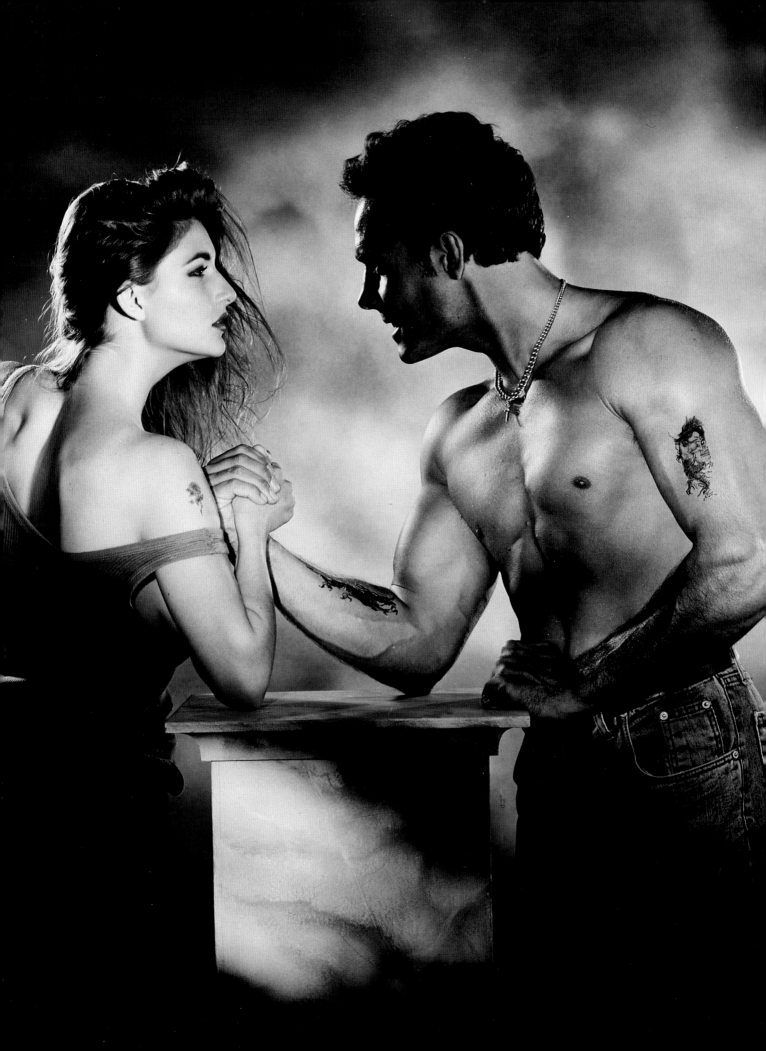

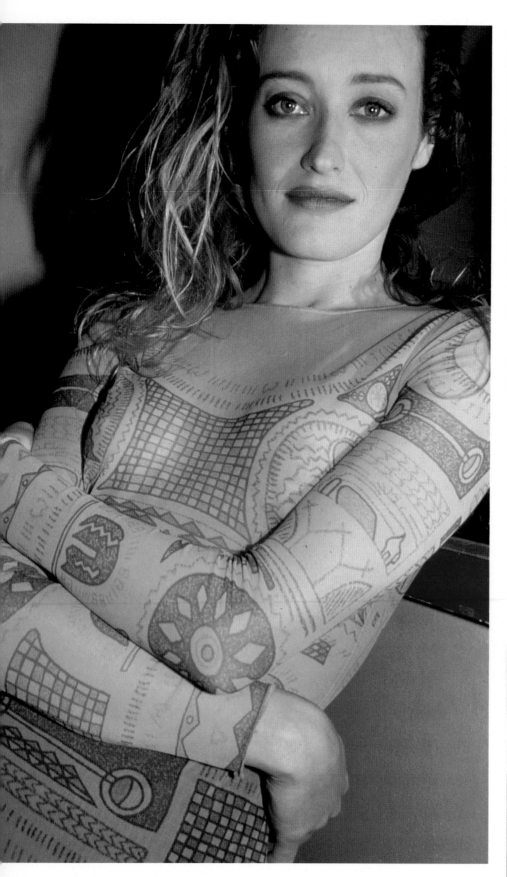

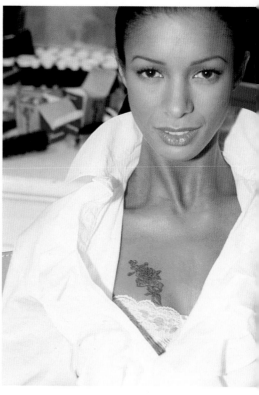

*T*attooing has greatly influenced the fashion industry; models sporting tattoos, including a fake tattoo top (left).

FLATTERING IMITATIONS

The recent explosion of interest in tattooing has led to a corresponding increase in the manufacture and design of temporary tattoos. You can find packets of brilliantly colored, imaginative tattoo transfer designs in most cities. The designs are more varied than they were in my youth, mirroring the often-quoted tattoo shop homily, "Your imagination is our only limitation." If today's temps are very different from those sad little design sheets of yesteryear, it is because most transfer companies now hire some of the top tattoo artists in the world to design their artwork. Nowadays, your choices in temporaries run the gamut from badly produced, sentimental designs to wonderful examples of tribal, fineline and oriental work.

Some of the traditional designs, like the ever-popular 'mom' heart, anchors, roses and assorted dragons, panthers and tigers are being replicated and, when manufactured by some of the better transfer companies, are visually exciting and impressive.

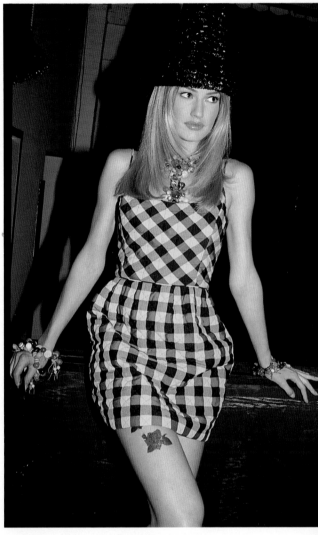

Temporary tats give Anna Sui's fashion designs their distinctive edge - she was one of the first to use fake tattoos on the runway.

Carefully applied, these temporary tattoos can sometimes pass for the real thing; a light dusting of baby powder can help to set the temp and make it look even more realistic.

Sometimes, however, these temps can last longer than you might want them to. A couple of years ago, movie star Elizabeth Taylor covered her arms with temporary tattoos to 'fit in' at a motorcycle run that she attended with the late Malcolm Forbes. Days later, poor Liz was at her dermatologist trying to find out how to get her temporary tattoos off! She must have used a particularly stubborn brand, as most are easily removed with either soap and water, or rubbing with alcohol or an oil-based cleansing cream.

Tattoos have recently become such a fashion statement that many designers ask their models to wear temps on the runway - perhaps to give their clothes that certain sharp edge of street style. Others, like

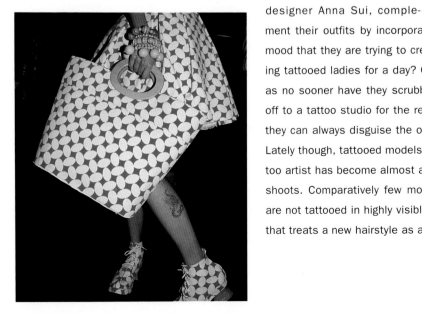

designer Anna Sui, complement their outfits by incorporating specific tattoo motifs to reinforce the mood that they are trying to create. How do the models feel about becoming tattooed ladies for a day? Obviously some have got bitten by the bug, as no sooner have they scrubbed off their temps than they have headed off to a tattoo studio for the real thing. If the next client doesn't approve, they can always disguise the offending mark with a skin cover-up product. Lately though, tattooed models are in such demand that the temporary tattoo artist has become almost as necessary as the make-up artist at photo shoots. Comparatively few models are tattooed, and almost all of them are not tattooed in highly visible areas. Professional caution in a business that treats a new hairstyle as a radical event does not encourage truly per-

47

manent, high-impact changes to the body, the model's most important commodity. Enter the temporary tattoo, the only way to get that eye-catching tattooed look that so many of the glamor magazines have been featuring lately. Chances are, if you're looking at a picture of a professional model who is heavily tattooed, you are also looking at fake tattoos. Carré Otis, a model who has half a dozen good-size pieces scattered about her body, is a notable exception.

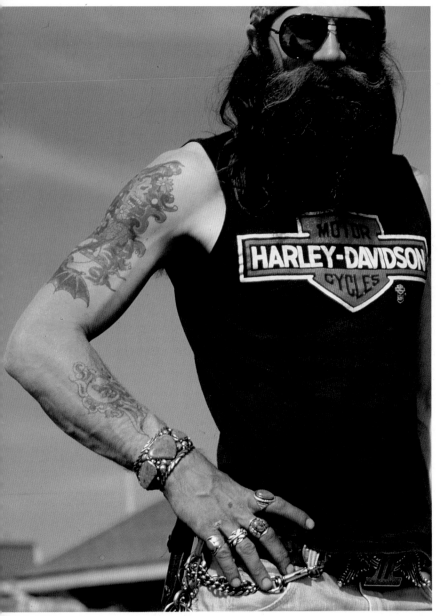

RARING TO GO
Biker-oriented designs are also now available, although it is quite hard to imagine anyone who would be entitled to wear such a design opting for a temp. Temporary tattoo booths do, however, exist at various bikers' meets. At these events, temps generally seem to be worn more in a spirit of fun - like a big set of Harley wings applied to the forehead - than as a serious fashion statement. There are exceptions to this as I have seen a couple of 'wannabe' bikers sporting obvious fake tattoos at some of the big motorcycle festivals. Bikers are usually quick to spot a phony though, be it a person or a tattoo, and do not hold much truck with such manifestations. I would not advise you to plaster your skin with a fake tattoo declaring 'Live to ride and ride to live' if you intend going to the local biker swap meet, unless you are a very small child. Bikers tend to put temporary tattoos into the same class as those people who adorn themselves with black leather, Harley-Davidson T-shirts, rings, bandannas and bike boots but who have never been on a motorcycle in their lives. Weekend bikers are not appreciated by those who hold the biker lifestyle, with its attendant tattoo culture, as sacred.

Tattoos have long been an integral part of the biker lifestyle (left). Robert De Niro in Cape Fear; when tattoos show up in a film you can bet the character who is wearing them is about to display some violent tendencies (page 49).

On the other hand, many enterprising children of tattoo artists set up little temporary tattoo booths at tattoo conventions, charging a small fee to other kids, as a way of getting into the spirit of the event. Not only is this a way for the kids to enjoy themselves, but I've even seen some Best Tattoo Of The Day awards go to kids who have, during the day, enthusiastically covered themselves with temps.

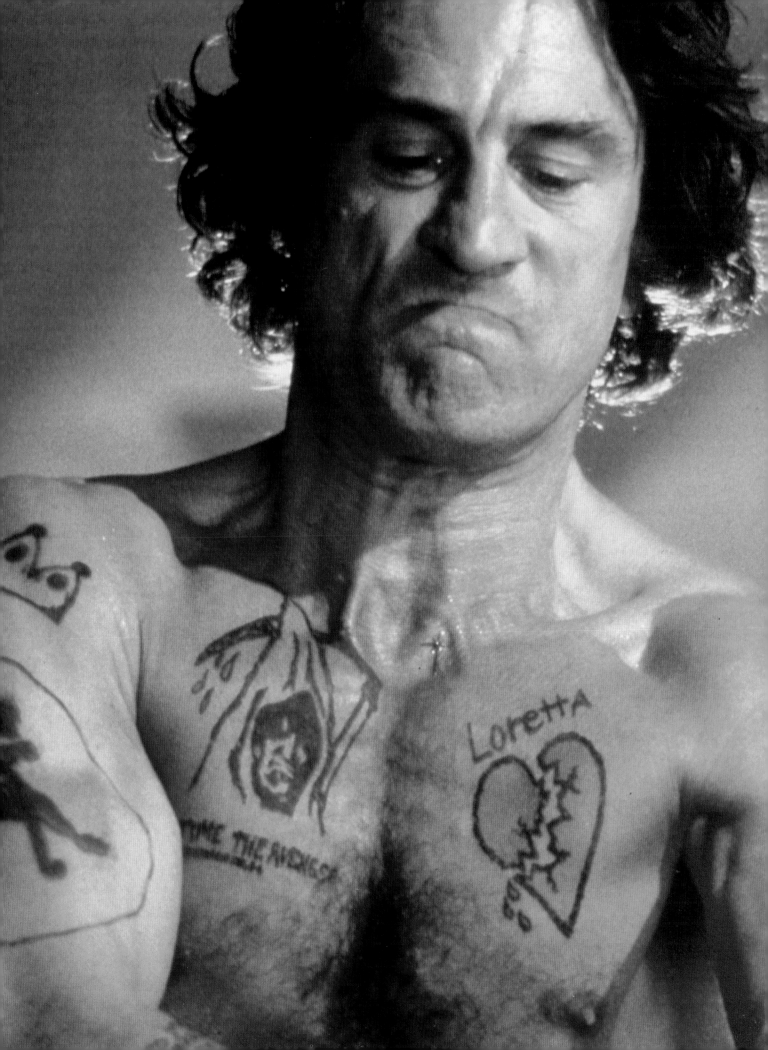

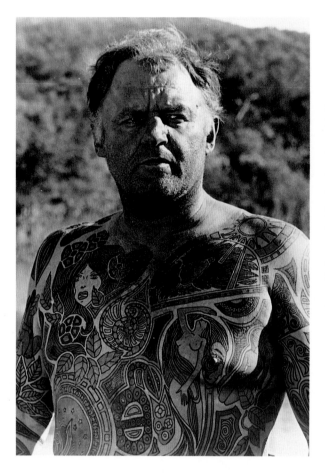

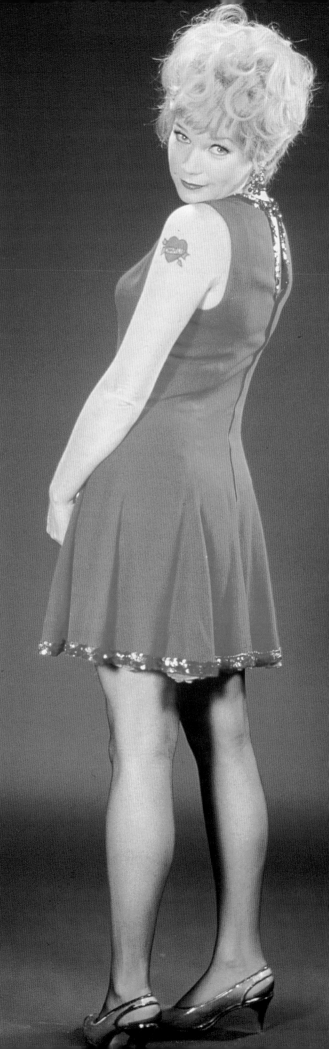

*T*attoos in the movies: Rod Steiger in *The Illustrated Man*, a film based on a novel by Ray Bradbury (above). Shirley MacLaine in *Sweet Charity* (right).

It is hard to imagine a street festival nowadays that didn't have room for a temporary tattoo booth. Sometimes these booths are actually manned by tattooists who see temporaries as a way of introducing future clients to the joys of indelible body art. Tattoo artists are also enlisted to set up these booths at various public charity events and promotional extravaganzas, as the organizers of these events have been quick to notice that the temporary tattoo stand is often the most crowded, and can contribute a great deal to any fundraising effort.

MOVIE TRANSFERS

The film industry has also aided in the development of temporary tattoo art. Make-up departments in search of temporary tattoos that would survive under hot lights and through the other occupational hazards of film making have come up with techniques to create realistic-looking tattoos that will last, scene after scene, on a character. Hollywood has moved from using body paint to application methods that are much closer to silk screening. Many film studios also make a practice of hiring bona fide tattoo artists to oversee the design and application procedures.

The process of designing temporary tattoos for the movies can involve almost as much research and effort as designing the real thing. Much thought goes into coming up with designs that will work with the character and give the audience visual clues about the actor's assumed personality. Of course, until very recently, putting some temporary tattoos on an actor was an instant way of telling the audience that this was an evil, nasty and possibly psychopathic character. For in most Hollywood movies, the guy whose burly arms are covered in tattoos is nearly always the one who starts a cell block riot, or a sailor who picks a fight in the bar. Unfortunately, tattooed people still sometimes get a

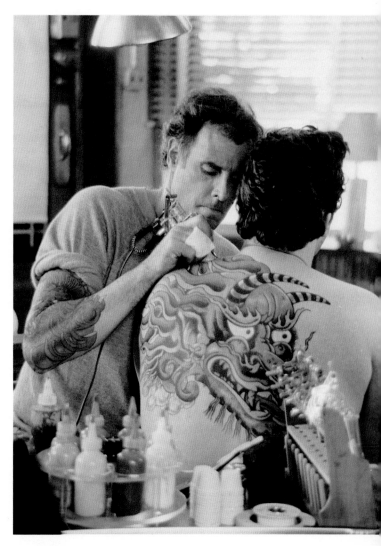

Bruce Dern starred as the obsessive tattoo artist in *Tattoo*, a film released in 1981, about an odd love affair (above).

> "*I*N MOST HOLLYWOOD MOVIES, THE GUY WHOSE BURLY ARMS ARE COVERED IN TATTOOS IS NEARLY ALWAYS THE ONE WHO STARTS A CELL BLOCK RIOT"

raw deal in movies, such as in the remake of *Cape Fear*, where a lingering shot early on in the film of Robert De Niro's tattoos was meant to indicate the leading character's violent, crazed nature. Other more recent temporary tattoo credits include another De Niro film, *Goodfellas*, *Wild Orchid* with Mickey Rourke, *The Rookie* with Clint Eastwood and *Cry Baby* with Johnny Depp.

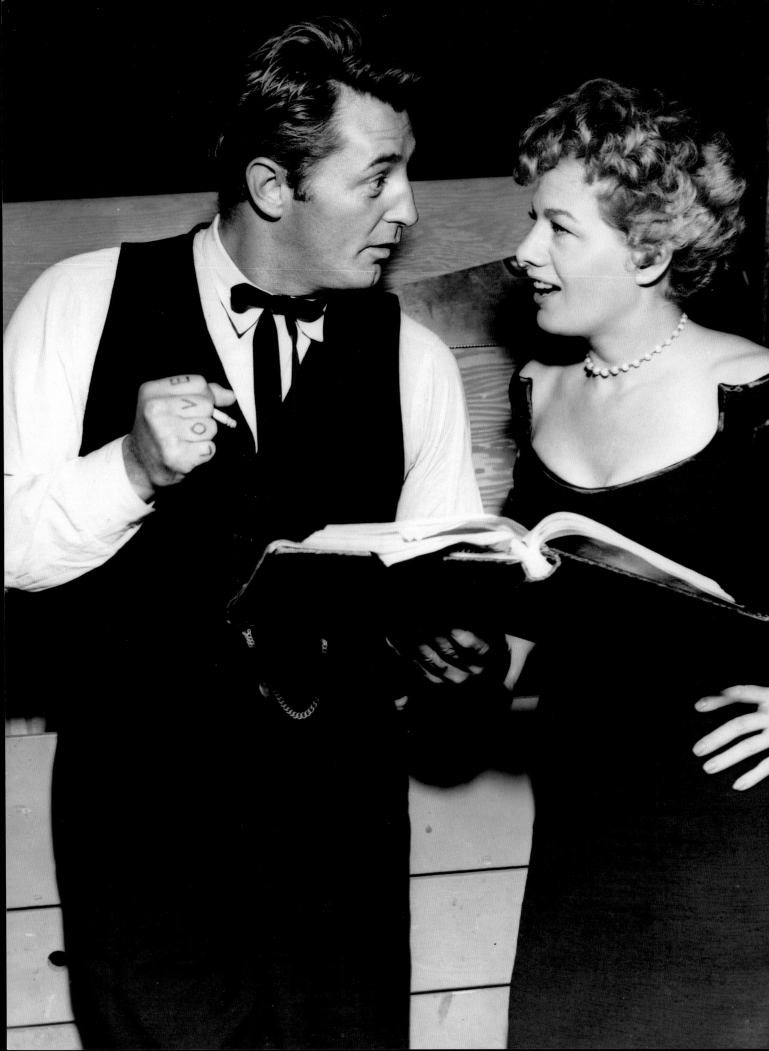

Temporary tattoos made for use in the entertainment industry are not necessarily a pretty sight. They are often modeled after the worst of prison-style tattooing and are meant to look rude and crude, as directors are out to make a specific point, trying to show, for example, that a character is so out of touch with mainstream values and aesthetics that he'd allow anyone to scrape this junk into his leathered hide.

DESIGNED TO FADE

The temporary tattoo market is, at the moment, very stylish and sophisticated, in keeping with the current acceptance of tattooing as a valid art form. Although it is currently fashionable to get a tattoo indelibly inked on your body, if they suddenly become déclassé overnight, they can not be hidden away in the darkest recesses of your closet until next time the fad resurfaces. A temporary tattoo is, therefore, a cheap, easy and painless way of achieving the desired effect.

Robert Mitchum in Night Of The Hunter (page 52). Goldie Hawn's body paint from the Laugh In (below).

> *"For those who see tattoos as an erotic statement there are even flavored temporary tattoos designed to be removed by your partner's tongue."*

For those who do not want to be so rebellious as to go for the real thing, temporary tattoos provide an exciting form of body decoration, something to be worn like jewelry for a special occasion. Nowadays, for those who see tattoos as an erotic statement, there are even flavored temporary tattoos designed to be removed by your partner's tongue. Not to mention the availability of scented transfers that give off perfume with body heat. If you are thinking of getting a tattoo primarily because they are hip and cool, I suggest you buy a packet of temps instead. Although you may be able to pass these off as the real thing in dark bars and nightclubs, it is probably best to admit that they are fakes, if only to avoid being engaged in a long, rambling discussion over their origin with some heavily tattooed person. Temporary tattoos should be worn in a spirit of fun, as a new, and slightly daring, fashion accessory.

The best thing about temporary tattoos is that they let you experience life as a tattooed person before you make that irrevocable commitment. Being blatantly tattooed is like being pregnant; suddenly strangers on the street feel that they have every right to comment on, and quiz you about, your physical appearance. Even the enquiries of well-meaning folk can be tedious after a while, as you tend to get asked the same questions over and over: "Did it hurt?" "How long did it take?" "How much did it cost?" If you are not sure of your ability to deal with the stares, the questions, and the whispered comments on a daily basis, you are probably better off sticking to the removable type of skin art!

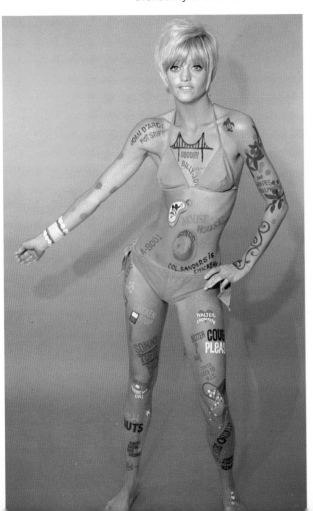

expo

Flip through the pages of any tattoo or biker magazine and you'll see advertisements for a 'Tattoo Expo,' a 'Tattoo Convention' or a 'Tattoo Tea Party.' These ads draw thousands of tattoo enthusiasts to conventions staged in various locales around the world.

But what exactly is a tattoo convention? Why do people go, and what happens at them? Tattoo conventions, as we now know them, really started in the early Eighties in California. That's when Ed Hardy, an American tattoo artist, decided to put together a convention that would be fun and would also give tattooists some real information about their art. Certainly conventions existed before this show, but they were more like social gatherings or, as Ed pointed out: "It was like, welcome to the convention, glad to see you all. The bar is over here. The other bar is over there. The buffet is here. We'll see you all tomorrow at the contest." While these conventions were undoubtedly entertaining, there was no structure to encourage any serious exchange of knowledge, neither between the artists nor between the artists and their prospective clients. By contrast, Ed's convention featured slide shows, films and workshops by tattoo artists and, for many, it marked the beginning of the tattoo renaissance.

Ten years ago there were only about three conventions being held a year. Now you could easily attend one a month in the United States alone. Add to this all the events that are also being held in Europe and Australia and you'd soon realize it would be almost impossible for a mere mortal with a limited budget to attend them all.

Every tattoo fan should, I believe, try to make it to at least a couple of these events. Why? Because they are probably the only place where your skin art will be appreciated by lots of people who have also been under the sharp end of a tattoo machine. While folks on the street or beach may react to your artwork (either with interest or dismay), most of them just won't understand that a world-class artist worked on your particular piece, that it took months to plan and hours to get, that it's positioned in a particularly sensitive area and yes, of course it hurt, but that's not really the point. At tattoo conventions people will respond to the quality of your art, not to the fact that it's inked into living flesh. You will be asked intelligent questions about your tattoo collection, not the usual "Does

*T*attoo conventions are the perfect place to display your tattoos to an audience who appreciate and understand the art. In tattooing, the medium conveys the message - as these people show.

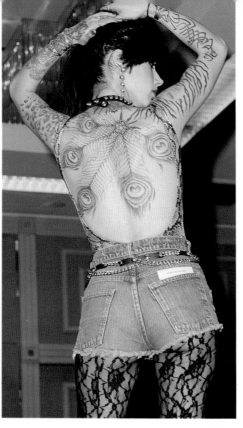

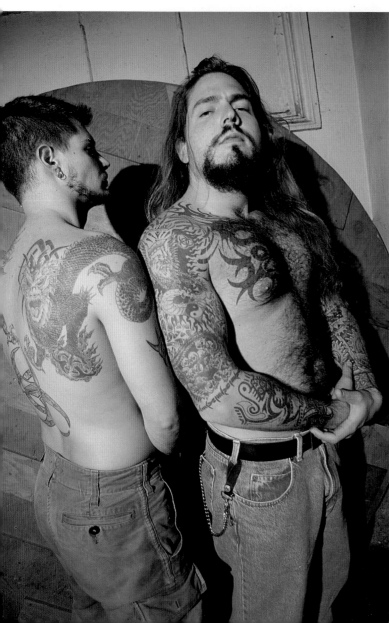

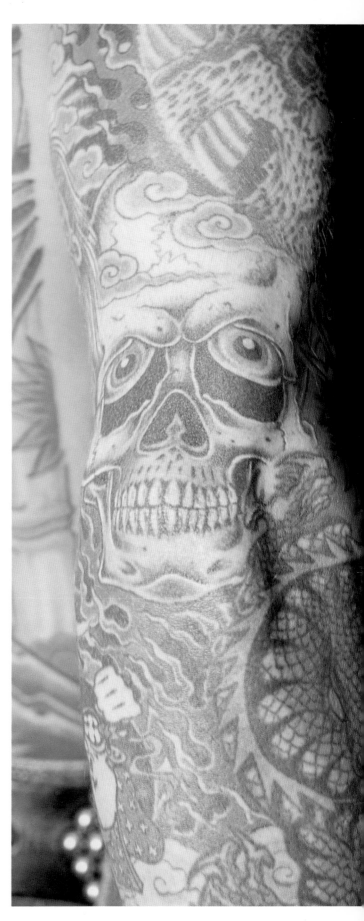

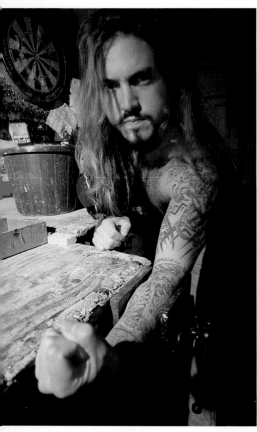

it come off? Did it hurt? How could you do that to your body?" For people at tattoo conventions love tattoos, they live, breathe, eat and sleep tattoos, and will greet another person's carefully composed tattoo collection with the respect and interest it deserves. Conversely, if you've just got an assemblage of poorly executed junk, the simple fact of being tattooed won't impress anybody at a tattoo convention. For the tattooists, the conventions also provide a well-deserved opportunity to be respected as artists, rather than sneered at as practitioners of some strange and barbaric rite.

All that said, tattoo conventions can be really overwhelming for someone attending for the first time. What follows is a guide that can make your visit enjoyable and relatively free from stress.

Here three convention goers exhibit their collections: at Dunstable, an annual UK event (left); the annual US National Convention (below); also at Dunstable (page 57).

MAKING YOUR MOVE

The first decision to make is to choose exactly which event you're going to attend. Each has it own special personality: some are devoted to having a wild party, others are more serious and are dedicated to educating the general public, as well as celebrating the art of tattoo. Some are slanted for bikers, some draw the hard core tattoo fanatics, while others seem to draw a mixed crowd of folks who are into all types of body modifications. Many are some combination of all of the above. Almost all the events are great places to bring kids to, although there are a few aimed specifically towards open-minded adults.

The best way to get a feel for which event you might want to attend is to check out the coverage they get in the various tattoo publications. These features will tell you if an event is small (good for first timers and folks who don't want to have to deal with crowds) or if it's an all-out extravaganza. The photos will give you more idea of what you're getting yourself into.

Location is another good indicator of how busy an event is going to be. Any convention being held in a big, cosmopolitan city is going to draw the crowds.

Many tattoo conventions are held in hotels that, even with the usual group rate discount, can be expensive in relation to the services they offer. You should also be aware that some convention organizers deliberately book their events in a hotel that does not provide easy access to the local attractions. Why? Simply as a method of keeping folks in the convention hotel and ensuring that they patronize the event's vendors instead of going out and spending their cash in town. If you particularly want to do some local sightseeing, call the hotel where the event is being held and

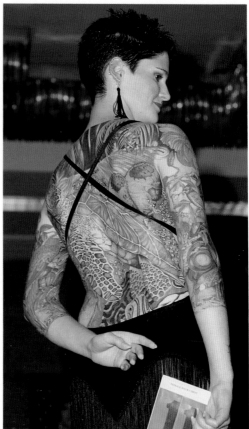

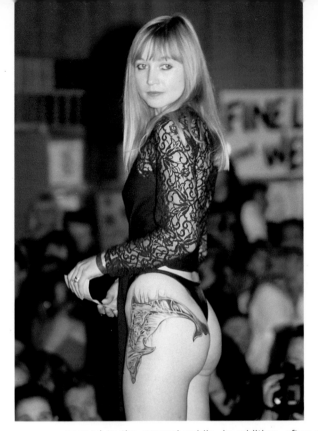

ask them how far away they are from the tourist attractions.

Despite the reservations outlined above, the best way to experience the event is to stay at the official convention hotel. The average tattoo convention will have enough activities to keep even the most hyperactive tattoo fanatic busy.

After deciding which event you're going to attend, pre-register with the organizers. Most conventions will charge you somewhere in the area of 50 dollars (US) for admission to the entire event. There are also rates for a daily admittance ticket; indeed some conventions only have day rates. However, if you're going to be there for more than one day, and there is a full package available, I would suggest you buy it, as this type of arrangement normally designates you as a 'registered guest' of the convention and entitles you to attend events that the day guests will not have access to. At most conventions, registered guests are admitted to many events well before the doors are opened to the general public. In addition, often only the registered guests are permitted to enter or vote in the tattoo competitions. You do not have to stay at the official convention location to be a registered guest.

The main point of pre-registering is that you'll get an information package before the convention, probably including a schedule of the events, a floor plan, contest entry regulations and various other interesting things to look at. Another reason for registering early for these events, especially if you want to stay in the convention hotel, or if you're a vendor, is that it is not unusual for them to be booked solid a year in advance.

Read the information contained in your registration packet carefully, especially if you want to enter your tattoo(s) in any of the contests. Every organizer has different rules for competitions. You may have to arrange for photos to be taken, or realize that you need special clothing, etc. At every convention I've ever attended I've always run into a few frantic folks who are trying to sort out the contest requirements a few minutes before they are due to sign up. Save yourself the aggravation and read the rules before you leave home!

BARING YOUR SKIN Well, you've

arrived. The first thing you'll see, which is rather overwhelming if you're a convention virgin, is an entire hotel or hall crammed full of heavily tattooed people milling around in various interesting states of dress or undress.

> "*DRESSED OR UNDRESSED, TATTOO COLLECTORS TEND TO BE A COLORFUL BUNCH ANYWAY, AND CONVENTIONS ARE ALWAYS A FEAST FOR THE EYES.*"

The point of these conventions is to show off the artwork, so people often slash or otherwise alter their attire to expose tattoos that are normally concealed by clothing. Dressed or undressed, tattoo collectors tend to be a colorful bunch anyway, and conventions are always a feast for the eyes.

Some convention organizers have strict rules of conduct and appearance. For example, the National Tattoo Convention specifies that all facial tattoos be covered and all facial piercing jewelry be removed for admittance to one of their events. Other conventions have a more laissez-faire attitude.

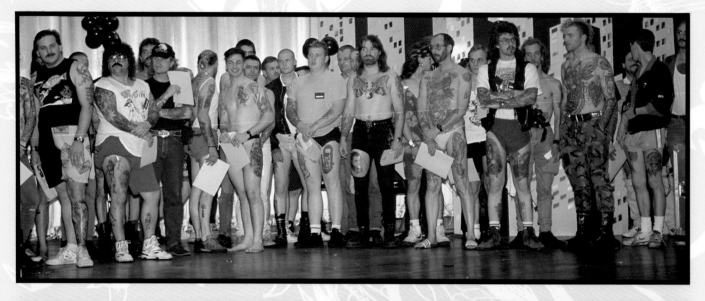

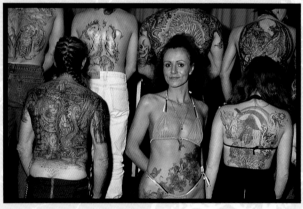

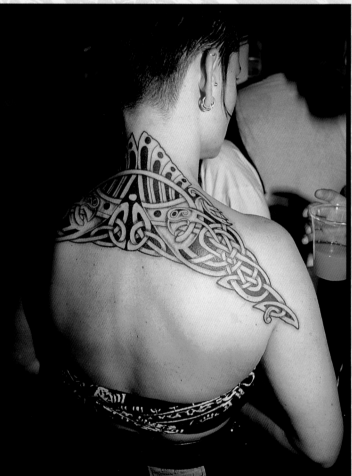

*L*ining up for the tattoo competitions at Dunstable (top and above left); getting a Celtic neckpiece (right and page 59).

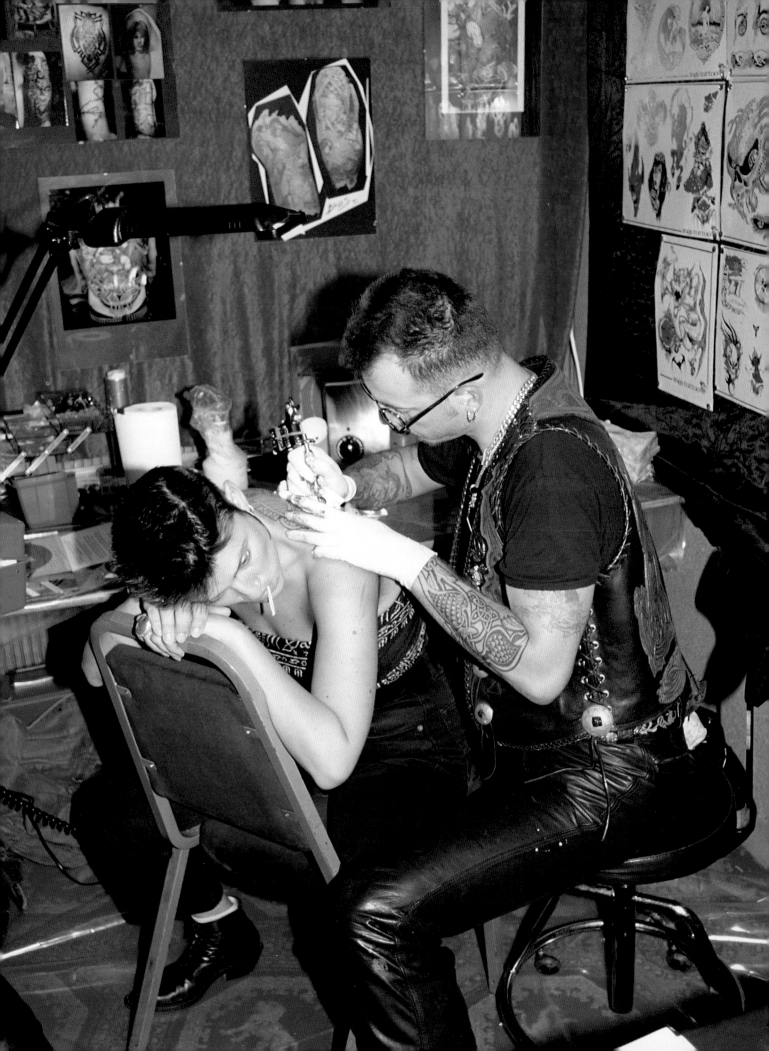

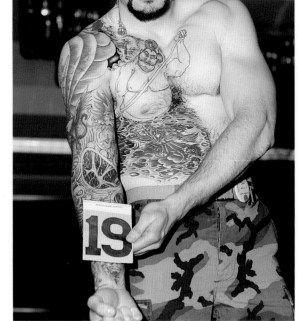

The first night of a convention usually features a welcome party and picture-taking session. This gives you an opportunity to get to know the folks you'll be living with for the next few days. If you bring your camera remember to ask permission before you take photos, as some people don't want their work photographed because they feel that it will encourage others to copy their tattoos.

WINNING DESIGNS

A big part of these events are the tattoo competitions, which often go on for a solid eight to ten hours. This is where you'll see the most dazzling examples of tattoo artistry.

Want to enter your own tattoos in the competition? The first thing to decide is which category you'll sign up for. Most competitions are broken down into the following categories: Best All Over Male and Female (for people who have extensive tattoo work), Best Back Piece (usually one large piece), Best Sleeve (that's a fully tattooed arm), and Best Leg Piece. Apart from body location, tattoos are also judged by their specific styles, such as Best Black and Gray, Best Tribal, Best Portrait, Best Traditional Tattoo, Most Realistic Tattoo and Most Unusual Piece. There are also awards for the artists, such as Best Artist Of The Year, Best Up And Coming Artist, and more awards for the tattooists who have drawn the best design sample sheets or flash. If your artist has done an exceptional piece on you, entering it in a contest is one way of saying thank you.

What are your chances of winning? This will depend on your tattoos, as all the major competitions draw entries of incredible quality. If not winning is going to ruin your entire vacation, it is probably a good idea not to enter the contest at all.

Here are some hints to help tip the odds in your favor:

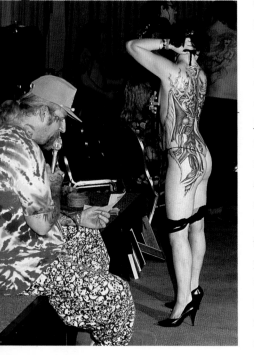

● Make sure your tattoo is entered in the right category. As a judge, I've had people present tattoos of mermaids and other mythological creatures to me in the Most Realistic category, colored pieces in Black And Gray, and really banal work in the Most Unusual section. Entering your work in an inappropriate category guarantees that your otherwise great piece will not win.

● Don't enter the same tattoo in every possible category. By the time the category that you might have won takes place, the judges will be tired of looking at you and your piece.

● Wear clothing that will show the work, as well as how the tattoo works with your body structure. Competitions are often on a tight time schedule and no one has time to look carefully at your tattoo after waiting for you to rearrange your clothing to show the piece.

> *"A HOT, NOISY ARENA, PACKED WALL TO WALL WITH SWEATY PEOPLE, MANY OF WHOM WILL BE SPORTING BANDAGES"*

● Do apply a little cream or oil on the piece to get rid of flaky skin but don't drown yourself in so much ointment that the tattoo is no longer visible.

● Don't overreach. If you've got a couple of good pieces on your arm you might be better off entering them in individual categories instead of going for a Best Sleeve award.

Good luck!

PUSHING INK

The hub of activity at tattoo conventions is the room where the tattooists and vendors set up. This is where you'll buy that T-shirt, mug, poster or other important souvenir; it is also where most of the actual tattooing takes place. You'll be able to find this room without the aid of a hotel map by following the sound of hundreds of tattoo machines buzzing, as well as by the aroma of green soap.

This is where you will find the crowds. A hot, noisy arena, packed wall to wall with sweaty people, many of whom will be sporting bandages over their freshly inked tattoos. At times it will look like a refugee camp for citizens of a particularly festive nation.

Do you want to get tattooed at a convention? Maybe. It's a great opportunity to get a piece from an artist who lives and works far away from your home. However, you may well have to pay a little more than you would in the artist's studio and, unless the artist is tattooing in a private room, you'll have to get your piece right out there in the middle of the convention, in front of a large, inquisitive audience. For shy people, that may be just a bit more than they want to deal with. On the other hand, you'll have plenty to distract you from the tattoo process and the boredom attendant upon sitting perfectly still for long periods of time.

If you want a tattoo from a specific artist, call their studio, find out if they are planning to attend, and try to book an appointment for the convention in advance. You may have to send a deposit. It's worth the extra effort if

you have your heart set on getting work from someone special.

If ink fever does hit you while you're at the convention, remember that just because an artist has a booth does not necessarily mean that his or her work is good. Choose your artist carefully. Look at his or her portfolio or photo album. Do you want to wear work of this style and quality for the rest of your life? If the answer is yes, great - go ahead and book an appointment. Whatever you do, don't settle for work by an inferior artist just because you think you need to get a tattoo now. The urge will go away eventually but the tattoo won't.

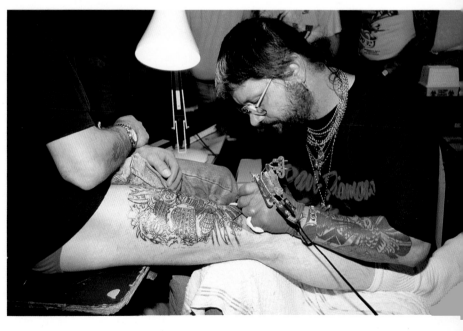

HEALTH AND SAFETY

Many tattoo conventions have strict sterilization and sanitation guidelines for the artists to follow. These may be detailed in your convention guidebook or information sheets. If not, use common sense and, if in doubt, don't be afraid to ask the artist about his arrangements for sanitary procedure when you make your appointment.

There's also a particular set of health problems that seem to plague conventions and which can often ruin a person's stay. Most of them originate with exposure to hot,

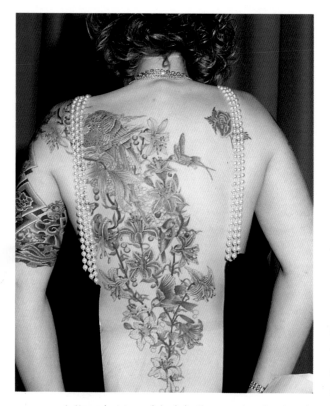

smoky rooms, dehydration, lack of sleep, inadequate nutrition, and overindulgence in various mood enhancers. The most common are the classic convention headache and sore throat, which can be avoided by drinking lots of bottled water and getting out into the fresh air, even briefly, a couple of times a day. I'm not trying to sound like anybody's mother here, but I've suffered a few bouts of convention ills myself. I suggest that you drink plenty of water and take a break from the convention occasionally. You'll thank me later when your friends are nursing headaches and chewing aspirin like candy.

It's also best to arrive at a tattoo convention assuming you are going to get a tattoo. Pack your healing ointment of choice and clothes that will allow the piece to get air. I once had an overwhelming urge to get

The Best Back Piece competition brings some of the most intriguing work to the stage. Award-winning work at the US National event (this page). Competing at Dunstable (page 63).

tattooed at two o'clock in the morning. I got a piece on my ankle. The next day I realized I had no healing creams with me and had packed nothing but tight jeans and knee-high boots. Tattoos do not heal well when they are smothered by layers of fabric and leather so I ended up slashing a favorite pair of jeans to the knee and walking around in horrible, uncomfortable plastic pool sandals that I bought at the hotel gift shop. Be prepared.

> **"*I ENDED UP SLASHING A FAVORITE PAIR OF JEANS TO THE KNEE AND WALKING AROUND IN HORRIBLE, UNCOMFORTABLE PLASTIC POOL SANDALS*"**

Attending conventions is a great way to become a part of the tattoo community. Often lifelong friendships are started at these tattoo conventions: careers begin or end; people meet, fall in love, decide to get married,

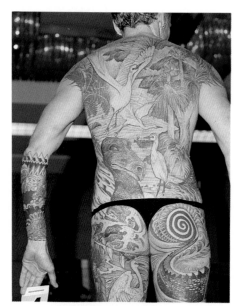

conceive children and even mourn their dead at them. It constantly amazes me just how much is going on under the surface at these magical gatherings of the tattoo tribes.

CONVENTIONAL FUN
If you've decided to attend a tattoo convention, here's where to write for more information on specific events. For more events check out your local tattoo and music magazines.

THE NATIONAL TATTOO ASSOCIATION
PO Box 2844
Lehigh Valley, PA, USA 18001
This organization sponsors the largest tattoo convention in the United States. The conventions take place in a different city each year in the US. National's events always bring out the best tattooists and the best work.

TATTOO TOUR
4138 East Grant Road
Tucson, AZ, USA 85712
Conventions organized by two long-time tattoo devotees. Their conventions are well organized, and very well attended by world-class artists. They sponsor two events a year, in different cities in the US.

INKSLINGER'S BALL
C/o Gil Montie
8861 West Sunset Boulevard
Hollywood, CA, USA 90069
Fun and funky weekend tattoo event held in Hollywood's famous Palladium.

MAD HATTER'S TEA PARTY
50 Old Orchard Road
PO Box 716
Old Orchard Beach, Maine, USA 04064
A terrific show! It's held the second weekend of February and it's well worth braving Maine's fierce winter weather to attend.

AM-JAM'S TATTOO EXPO
PO Box 4709
Schenectady, NY, USA 12306
A great weekend tattoo party, which is held in the second weekend of January in northern New York. A good way to beat the winter blues.

AMSTERDAM EXPO
C/o Hanky Panky's Tattoo Studio
OZ Voorburgwal 141
Amsterdam, The Netherlands
An exciting event, not to be missed.

PROFESSIONAL TATTOO ASSOCIATION
New South Wales Branch
PO. Box 250
Vaucluse, NSW, Australia 2030

TATTOO EXPO
118 Shirley Road
Southampton, Hants, SO1 3FD England
Great annual show, held mid-September, which draws many excellent artists from Europe and the USA.

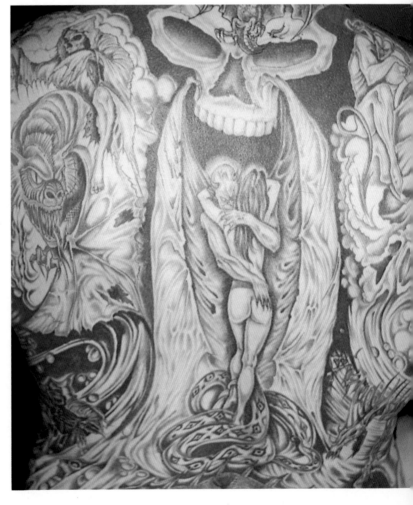

world

It is thought that tattoos probably originated around the time that humans discovered the myriad uses of fire. I imagine somebody grabbing for a chunk of meat and accidentally getting a puncture wound from a sooty stick.

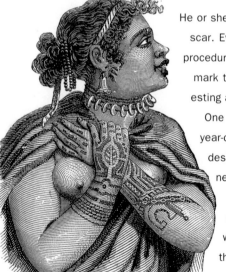

He or she would have been left with a lesson in table manners along with an interesting scar. Eventually, these ancient dwellers may well have caught onto the fact that this procedure of cutting the skin and adding soot or other pigments could also be used to mark the skin by choice. Marking the body in this way must have provided an interesting alternative to painting those musty old caves.

One of the oldest surviving examples of tattooing has been found on the 4,000-year-old mummified body of an Egyptian royal child. The youngster had a sun god design pricked into his skin with a bone needle; the tattoo was then made permanent by rubbing a mixture of animal fat and soot into the wound.

Tattooing flourished in many early cultures. The Celtic tribes tattooed themselves using pigments extracted from the plant woad (the distillation process was so messy and foul smelling that the families who worked with woad were segregated from the rest of the tribe). The Pictish people got their name from the pictures that they carved into their flesh. These early tribes, like Native Americans, used tribal markings as a form of war paint, designed to intimidate and confuse the enemy. Julius Caesar in his book *The Gallic War* remarked upon the terror that the tattooed Celtic warriors inspired in their foes: "They are fearful to look upon in battle."

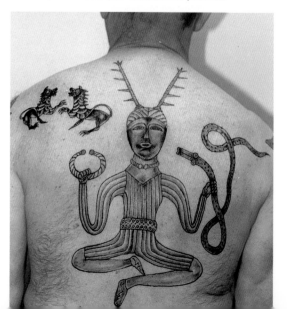

Many Native American tribes practiced forms of tattooing, some using thorns to make the punctures before rubbing soot or berry juice into the wounds. Another primitive form of tattooing was practiced by Eskimos, who pulled a soot-covered thread under their skin to turn their flesh into art. The ancient tribal practice of creating a tattoo by tapping a sharpened piece of bone into the skin using another bone or stone, is said to have given us the word tattoo – from the distinctive 'tau-tau' sound of bone upon bone.

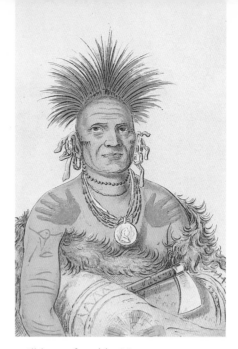

Primitive body art old and new: a woman of the Marquesas and a modern back piece of an ancient Celtic God (page 64). A Pawnee chief (above). A snake totem by Sting of Germany (below).

If marking or branding flesh was a way of showing an individual's membership of a particular tribe or clan, there is also evidence to suggest that some of the early tattoos were of a more personal nature. The recent discovery of the Iceman's corpse was one such example. Trapped inside a glacier for 5,300 years until he surfaced just two years ago, the Iceman's tattoos (blue parallel lines on his lower spine, a cross behind his left knee and stripes on his ankle) also survived the centuries of deep freeze. The most exciting thing to the anthropologists was the position of these tattoos, because the fact that they would have been hidden by clothing suggested that they were not meant as tribal identification markings, but instead were personal pieces, inked solely for the enjoyment of their owner and his mate.

Other primitive cultures seem to have codified their mythology and other important teachings into their tattoo designs. Representations of animals were tattooed onto the body in the hope that they would add protection or give their particular strength to the tattoo bearer. For example, a dolphin tattoo was thought to protect the wearer from sharks, because sharks were never seen in the same area as dolphins. In some island cultures, you will see triangle motifs incorporated into tattoo designs which puzzled anthropologists, since triangle shapes are rarely found in nature. Triangles were, however, found to be used extensively in navigation.

THE MARK OF A CIVILIZED SOCIETY?

Tattooing was quite popular in Europe during the Classical period until the Dark Ages when Christians expressed opposition to body modifications. The reason for this hostility was that Christians believed that since God created man in his own image, it was sinful for man to try to alter that image. As the penalties for not conforming to the orthodox religion were rather severe in those days, and nobody in their right mind would wish to be branded a heretic, tattooing all but died out for about a thousand years.

Then came the age of discovery, when men were obsessed with the idea of setting sail to strange and mysterious ports. The art of tattooing was something that these explorers rediscovered and appropriated, often in the process of destroying other native cultures.

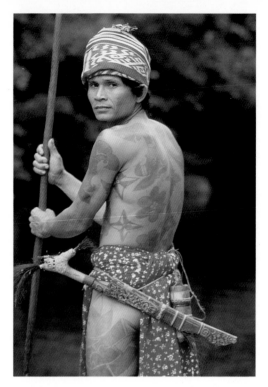

*T*raditional tattooing: Iban tattoos from Borneo (top right); a Maori king with Moko work (bottom right); a modern Maori man (below). A dancer from the Sarawak Dyak tribe (page 67).

Captain Cook's ship, the *Endeavor*, left port on August 16, 1768, with Joseph Banks, one of the most talented scientific artists of his day, aboard. After the ship had docked off Tahiti, on April 11, 1769, Banks started to document the native culture and made a number of references to tattooing in his journals, both to its prevalence ("Everyone is marked in different parts of his body according to his humor or different circumstances of his life") and practice. The tattoos themselves were described as depicting animals and human figures along with "beautiful circles, crescents and ornaments." The tattoo ink was derived from burning "some kind of oily nut" and the tattoo instrument itself was described as a saw-like object made from bone that was dipped into the pigment before being pounded into the skin with a small hammer.

The *Endeavor* also visited New Zealand, where Banks wrote the first account in English of Moko work, the Maori style of tattooing, which consists of beautiful, intricate and often curved patterns, usually inked on the face. It was a rather dangerous art form to wear, because particularly good examples of Moko work were prized as trophies among the head-hunter population.

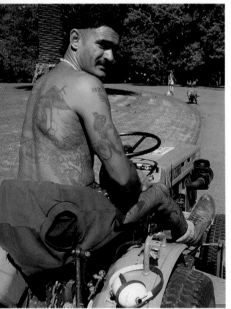

Another explorer, Captain Bougainville, who sailed around the South Seas during 1766-9, is credited with introducing the word 'tataou' into the English language.

Interest in tattooing in England was revived by a certain John Rutherford, who was captured by the Maoris in 1816. They tattooed him quite extensively until his rescue in 1821. Once back in England, he recounted his experiences at fashionable dinner parties, causing many of the upper-class men and women present to go and get a tattoo.

So from the Iceman 5,300 years ago, to reports that the bullet that started World War 1 passed through the snake tattooed on Archduke Franz Ferdinand's body, tattooing has always been part of human history. Tattoos may pass in and out of fashion, and are occasionally banned altogether, but nothing has yet managed to prevent human beings from customizing their bodies.

Many ancient myths abound about the nature of tattooing. Some state that your tattoos are the only thing you take into the underworld with you and that they are a way (in some cultures the only way) for your relatives and kindred spirits who have passed away before you to recognize you after your death. Without tattoos, you would wander the spirit world forever alone, in search of your loved ones.

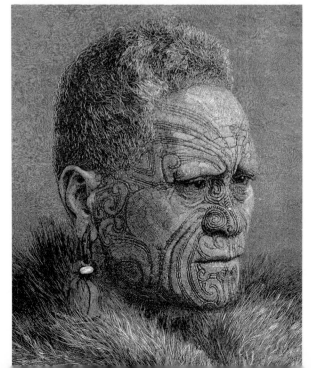

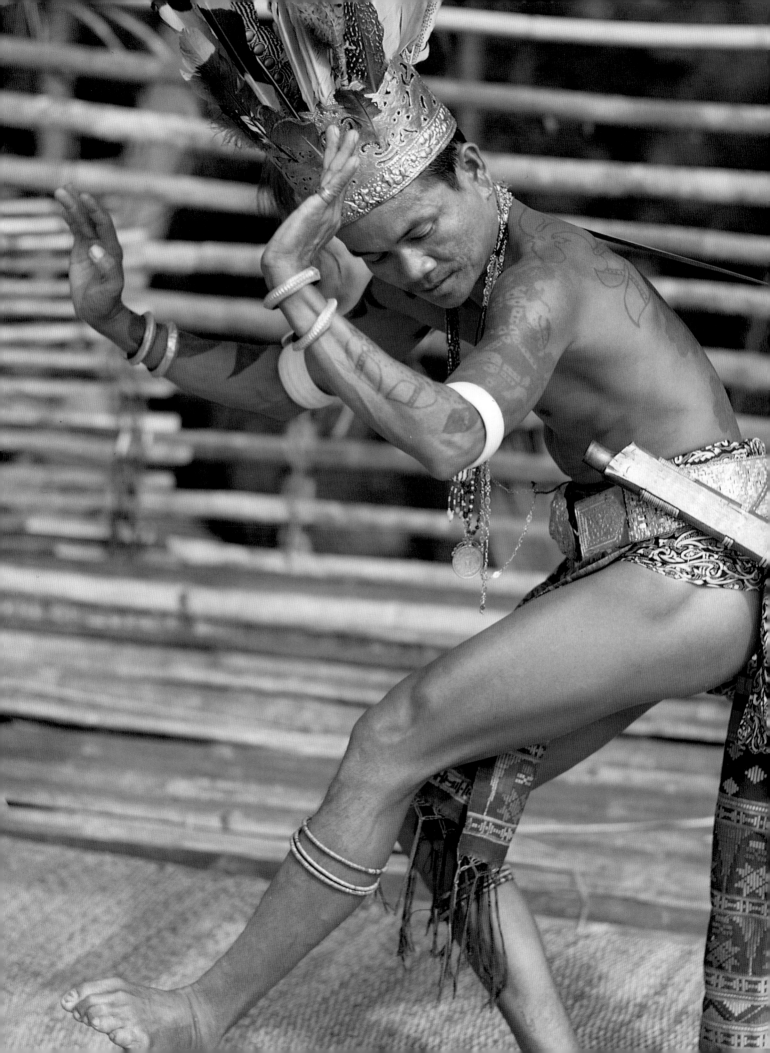

We would do well to study the traditional tattoo designs. After all, anything important enough to be engraved permanently into the skin must have had great meaning to the people concerned. The knowledge encoded in this ancient art may have much to teach us about living in harmony with the earth.

A GLOBAL CONCERN
Twenty years ago, before we began living in this ever-shrinking global village, there were distinct differences in local tattoo styles. The arrival of international tattoo conventions and publications, however, has led to girls in New York walking around with tattoo designs from Borneo, and Japanese boys with 'Elvis Forever' inscribed on their forearms. It seems nowadays that people look down on tattoos of historical significance to their own culture. Tattooists who have traveled to far-off places in the hope of getting to know more about a specific style of tattooing often report that the natives are more interested in getting anchors and pin-up

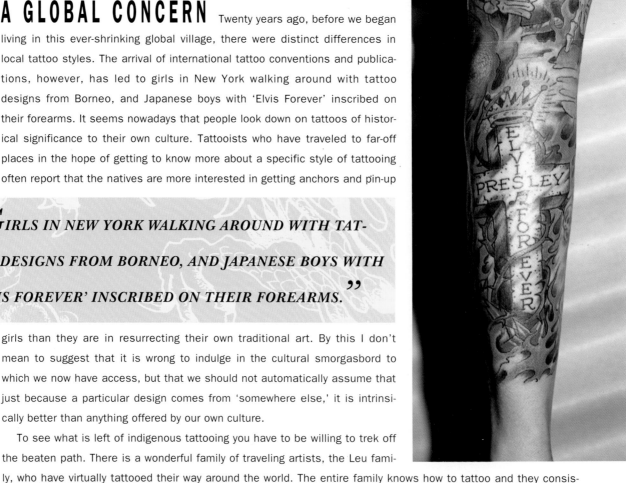

> *"GIRLS IN NEW YORK WALKING AROUND WITH TATTOO DESIGNS FROM BORNEO, AND JAPANESE BOYS WITH 'ELVIS FOREVER' INSCRIBED ON THEIR FOREARMS."*

girls than they are in resurrecting their own traditional art. By this I don't mean to suggest that it is wrong to indulge in the cultural smorgasbord to which we now have access, but that we should not automatically assume that just because a particular design comes from 'somewhere else,' it is intrinsically better than anything offered by our own culture.

To see what is left of indigenous tattooing you have to be willing to trek off the beaten path. There is a wonderful family of traveling artists, the Leu family, who have virtually tattooed their way around the world. The entire family knows how to tattoo and they consis-

tently turn out some of the most extraordinary work I've ever seen. Currently they tattoo in Ibiza, Spain and Lausanne, Switzerland. Of their time in India, Felix says, "We were living and tattooing in Goa for three years. I also tattooed for six months in Bombay, downtown Colaba, man! What a scene! Loretta and I tattooed mostly westerners, hippies, freaks 'n' travelers, but also Indians. Fishermen and a lot of Indians are into tattooing. First you get the tribal scene, of course, vast, man! What a field to study. And then there are the Christians and Hindus who are into it. They generally have their Gods, Jesus, Shiva, Hanuman, and so on, tattooed on their inside forearms, or they get crosses, or Om signs or hearts tattooed between their thumb and index fingers.

They get tattooed to mark that they have been on a pilgrimage. Pilgrimages are like a national sport in India. There are hundreds of feast days. And on the feast days the Hindus go to their temples. Outside the temples there will be maybe 20 tattooists, with people sitting, lined up, waiting, in front of them. These dudes work right off the ground, powering their machines by hooking them up to car batteries."

EASTERN INFLUENCES

In southeast Asia almost everybody, except the richest people in society, has a tattoo. Even if you don't want to get a piece permanently inscribed on your skin, the chances are you will still go to a Buddhist temple and get a design traced onto your body with sacred oil. Most of the tattoos are done for protection, and although visually they may be more crude than our stylized western designs, they have something special about them, a strength or soul that our more aesthetically sophisticated tattoos often lack.

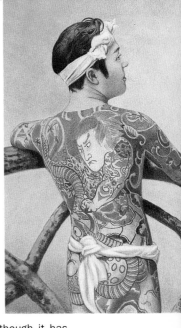

Japan has a rich tradition of tattooing, although it has become associated with the Yakuza (criminal) classes and other 'marginal' types of folk. Recently, the Japanese government made an effort to ban people with tattoos from the country's golf courses. As golfing is limited to those who can afford membership of a club, it is a sign of prestige within the culture and, due to the lack of open land in Japan, it is also very expensive. Somehow, the heavily tattooed Yakuzas were managing to buy their way in, leading to claims from the golf club managers that these tattooed members were terrorizing their non-decorated clients.

Despite the fear that tattoos evoked in the golfers, Japan has one of the most sophisticated tattoo traditions in the world. To start with, you don't just wander into a tattoo studio, pick your design off the wall and get tattooed. You need to have personal referrals before you can even entertain the idea of being tattooed by a traditional Japanese master: he will then choose the right design for you. The outline may be executed with an electric tattoo machine, but the shading and color will almost certainly be applied using needles attached to a handle, the traditional hand tool. Other Japanese artists say that a machine outline is 'dead' in comparison to one drawn by hand and may only

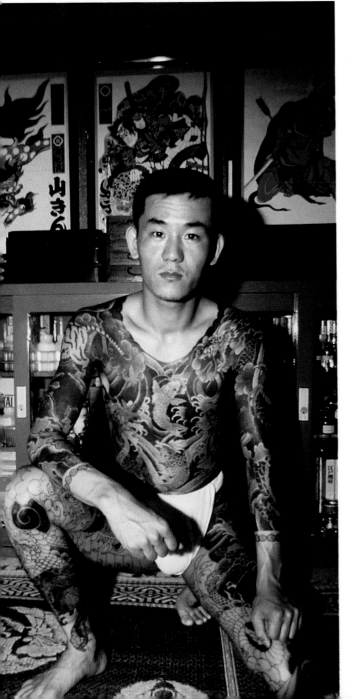

*E*lvis lives, arm piece done by Ed Hardy in Tokyo; Indian woman getting a pilgrimage tattoo (page 68). The oriental style of tattooing uses the entire body as a canvas (this page).

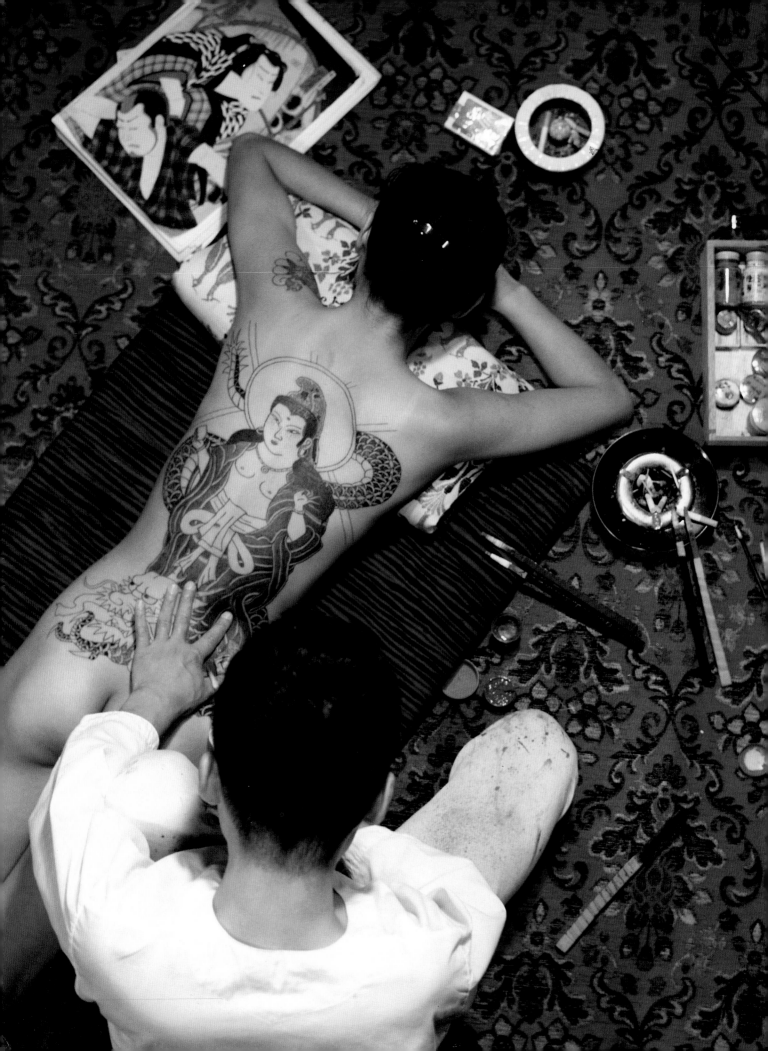

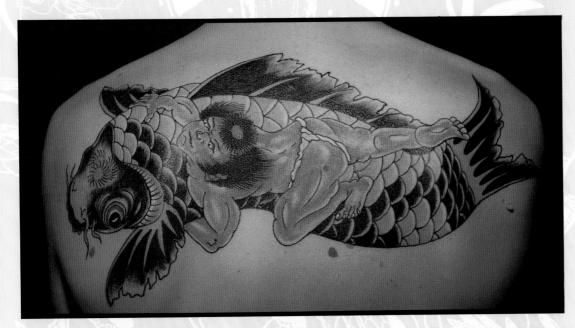

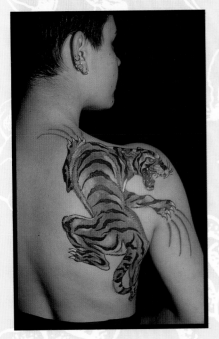

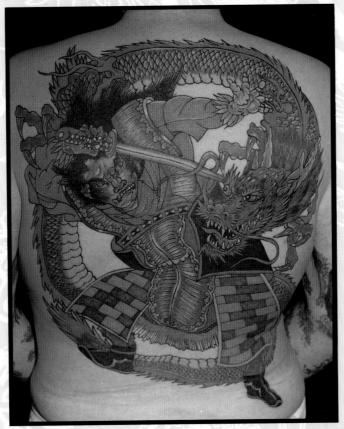

*P*ushing ink by the traditional hand method in Tokyo (page 70); two oriental-influenced back pieces and a traditional American-style tiger, all by Dennis Cockell (this page).

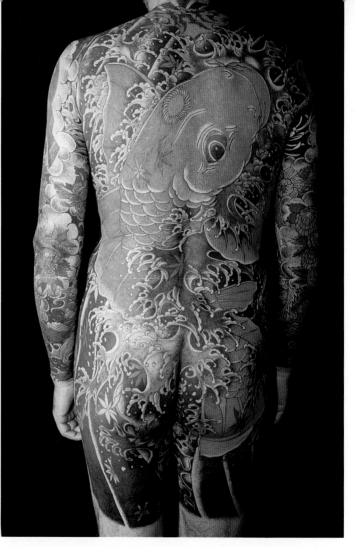

use the machines to apply large fields of color. Everyone that I have spoken to says that the 'by hand' or 'pushing ink' method of tattoo application is less painful than our western procedure. However, American tattooist Pat Fish, who has been tattooed in the traditional working styles of both Japan and Samoa, says that it was "eerie to feel the skin pop up from the muscle fascia as the needles went into my skin at an oblique angle." She also said that the Samoan method of pounding the design into the skin was absolutely the most painful of all: "It felt like the ivory tool was being hammered into the skin until my bones stopped it."

Kazuo Oguri described his traditional Japanese tattoo apprenticeship to Steve Gilbert, a freelance writer who works for *Tattoo Revue* magazine. Oguri served a five-year period under his teacher, during which time he lived with his master and, at the beginning, performed any necessary housework tasks. When he wasn't cleaning, he sat and watched his teacher tattoo. He didn't ask questions, he just observed, which he said was the traditional teaching style of Japan. "Words go in one ear and out the other," he said. "But after many hours of watching and thinking about what you have seen, you learn without words. This is the best way."

The Japanese tattoo tradition is based on copying designs that have been handed down for centuries: copies are still made of a teacher's collection of designs before they are passed onto the students. Many of the original designs were drawn by an artist named Utagawa Kuniyoshi.

A westerner who is heavily tattooed will often have the many different pieces on his body all tied together with some gray shading, almost as an afterthought. The Japanese style of tattooing uses the entire body by covering it with one large, well-conceived tattoo.

> ## "*IMAGINE HAVING SHARPENED BONES POUNDED WITH A STONE INTO THE FLESH COVERING YOUR STOMACH OR KNEES OVER A PERIOD OF FIVE DAYS* "

EAST MEETS WEST
Some of these oriental designs are such works of art that it is even possible to sell them. Proud tattoo bearers have been known to sign pieces of paper that bequeath their skin to the purchaser, in much the same way as your organs can be donated if you die. American tattooist, Ed Hardy, has written in his magazine *Tattootime* about the tattoo museum of Doctor Fukushi, started in 1926 by his father, who had figured out a way of preserving skins. Painter Robert Williams has also spoken about a man who wanted Williams to design a tattoo for him, but could not afford to pay for the work. He suggested instead that the painter accepted the

donation of his tattooed skin, to be collected after his death. Williams at first thought of accepting the offer, if only because of its novelty value, but eventually rejected it because this man was a biker, whose skin may not have arrived in pristine condition. Furthermore, he was advised by a medical friend that pickling human skin would be difficult, never mind causing problems with the authorities!

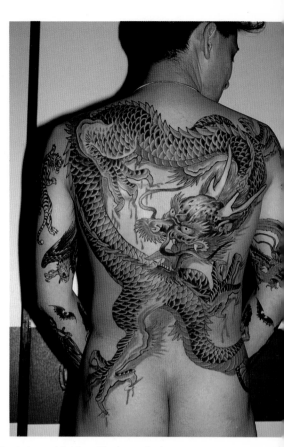

A MAGICAL EXCHANGE?
Tattooing is often a magical rite in the more traditional cultures, and the tattooist is respected as a priest or shaman. Some cultures tattoo young people at puberty, as proof that the adolescent has the courage to get a large tattoo and is, therefore, ready to take on the responsibilities of adulthood. This type of tattooing is a true ordeal. For example, in the Samoan tattoo ritual a young person will get a *pe'a*, a traditional tattoo that extends from the lower ribs to the knees, totally covering the area on both sides of the body. Imagine having sharpened bones pounded with a stone into the flesh covering your stomach or knees over a period of five days and you'll understand the challenge involved in this rite of passage. However, if you didn't have the courage to complete the tattoo you'd be forbidden to marry and take part in the normal activities of your tribe. Talk about peer pressure!

Many contemporary tattooists say that their job requires them to be both psychic and psychiatrist. They are dealing with the dream world, helping people to codify their desires into images. Some eschew the use of pre-drawn flash

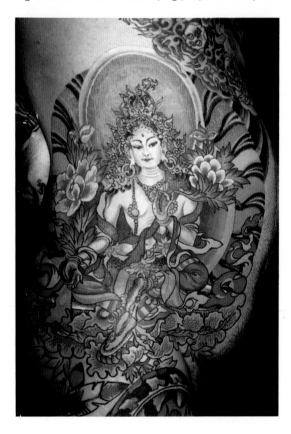

designs, preferring to sit with the client looking at photos of past work, as a way of encouraging them to point out what attracts or repels them in the various pieces. The next step is often to ask the client about their life, how it is now as well as about any future aspirations. From the information gleaned during this process, they design the tattoo.

Andrea, a tattoo artist who works in New York City, will often draw a design for a client before putting tissue paper over it and asking them to add to and change the design. She will repeat this process until the perfect tattoo arises from the layers of paper. Ed Hardy likens the procedure to the one adopted by a police department artist: "It's like trying to get the salient features of the suspect out of the person. You draw a little and you ask 'Is that it?' The person might then say 'No, this part needs to be a little different

*E*xtraordinary examples of oriental-influenced tattoo art from the west: back piece by UK tattooist Dennis Cockell (page 72). Back piece and side pieces by American artist Ed Hardy (this page).

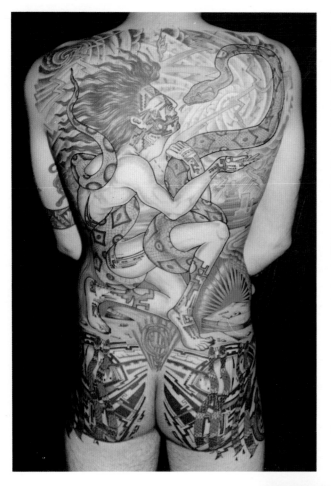

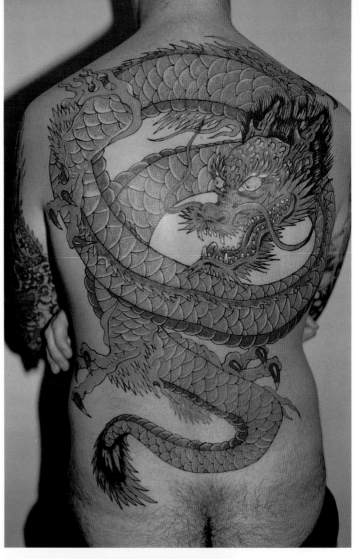

*S*nake back piece by Ed Hardy (top left); oriental dragon by Dennis Cockell (top right); dragon by Filip Leu (below). Tribal work by Vyvyn Lazonga (above, page 75), arm by Andrea (below, page 75).

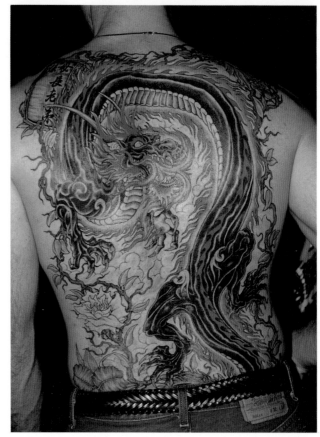

here.' Or 'Yes, that's exactly right!' Or perhaps I might say, 'It's right but if I move it a half inch and make it red rather than blue, will it be more right?' This collaborative process is one of the things about tattooing that really interests me."

Some tattooists in the West are experimenting with ritual tattooing. This method of working incorporates doing a ritual to create a sacred space in the area where the tattoo is to be positioned. Often incense is burned and the gods invited to bless the proceedings. Friends are asked to witness and lend their support and energy. The tattoo is designed taking traditional magical color correspondences into account and applied during the appropriate phase of the moon. This type of tattooing is often used as an initiation rite or for healing.

Magical tattooing doesn't have to incorporate a full-scale ceremony. Some of the most powerful magical tattoos I've seen are being inked by Seattle artist Vyvyn Lazonga, who has transformed clients into their totem animals with beautifully tattooed stripes, spots or feathers.

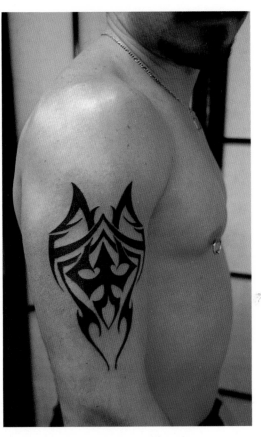

DRAWING THE LINE
In this culture, a tattooed person is still looked at as a rebel, as someone who has very visibly stepped out of the bounds of normal society, while in many traditional cultures a non-tattooed person would be the outsider. In some places, your body would not even be given a proper burial if you were not tattooed. Carrying on a particular family's tattoo design is seen to be as important as carrying on the family name is for an only child in western cultures. Getting tattooed makes you one of the tribe in this world, and ensures that you will be recognized as such by the ancestors in the next world.

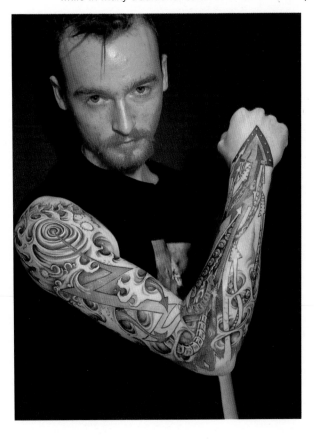

> "*T*ATTOOS ARE MORE THAN SKIN DEEP, YOU KNOW. THAT INK SURFACES FROM YOUR SOUL.*"*

Perhaps things have not changed that much after all. In a strange city, I will look for tattooed people because I assume that we share certain basic thoughts about life. Once you are tattooed you are a member of a worldwide tribe, and your tattoos can be a passport to gain entrance into some exciting and unique places.

Tattoos are more than skin deep, you know. That ink surfaces from your soul.

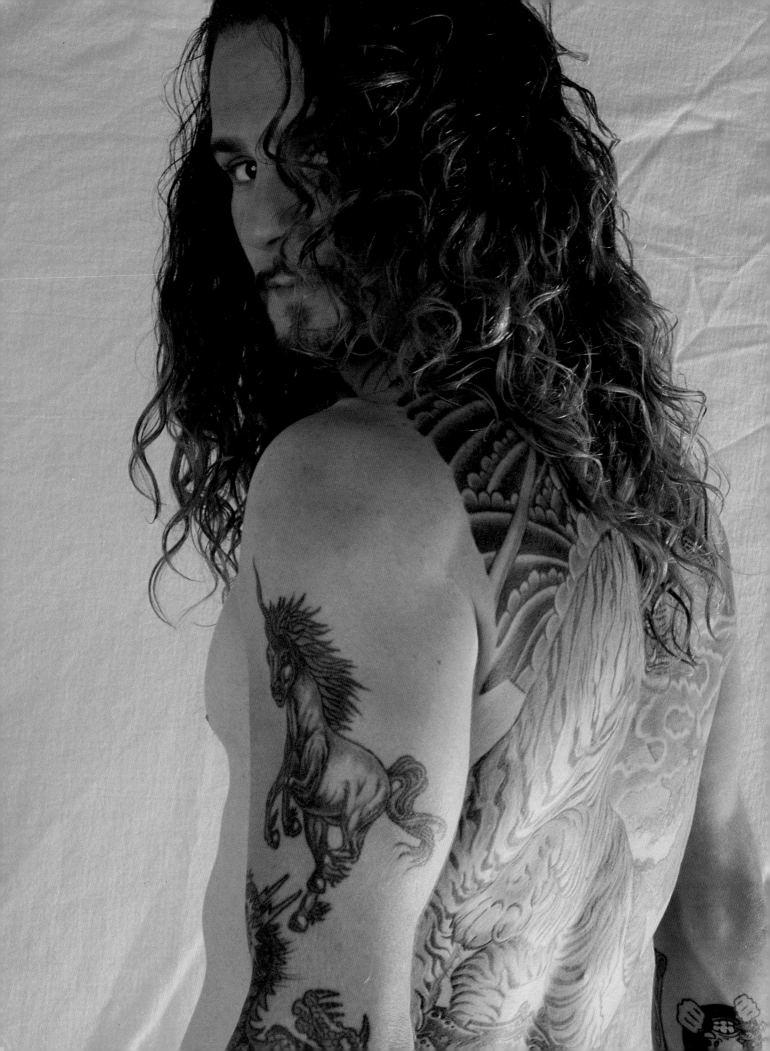

TATTOO TALK

A

After Care: Looking after your new tattoo once you get home.

Apprentice: Someone who is learning to tattoo the right way.

Art: What all tattoos should be. Sadly, some people devote more time to picking out art for their walls than they do art for their bodies.

Autoclave: A machine that's used to sterilize tattoo equipment.

B

Backroom: A work place to avoid. (See Scratcher.)

Blackwork: A tattoo inked only in shades of black and gray.

Body: (See Canvas.)

Bodysuit: Complete coverage of the body with tattoos.

Bold: A design that makes a strong graphic statement.

By Appointment Only: You shouldn't just show up at the studio.

C

Call Ahead: A necessary step if your artist works 'By Appointment Only.'

Canvas: The client.

Carve: Scary slang term for tattooing.

Clean: A technically perfect tattoo with solid lines and color.

Color: Using the full range of pigments.

Cover-up: A new tattoo that gets placed over an existing, unwanted one.

Custom: A tattoo designed especially for you.

D

Dermagraphics: Art on skin.

Done: What you really want to hear your artist say after you've spent a few hours getting tattooed.

E

Epidermis: The outer layer of skin.

Explosions: Splotchy, uneven lines in a tattoo.

F

Fall Out: Rapid fading, usually of color, from a new tattoo due to improper application. (See Scratcher.) Fall out can also occur due to improper aftercare or when a tattoo is placed on a part of the body that doesn't hold ink well, like the sole of your foot or the inside of your lip.

Fineline: A tattoo with a delicate outline (also known as single needle work), which lacks the bold outline and heavy shading of a traditional-style tattoo. Portrait tattoos are almost always fineline work.

Flash: Pre-drawn designs that often hang on the walls of a tattoo shop.

G

Gloves: Disposable medical-style hand wear that should always be used by a tattooist while he or she is working on a client.

Gun: Slang term for tattoo machine.

H

High Energy: 'New-style' tattooing, often based on comic book-style art but can refer to any tattoo that is bold and colorful.

Holidays: Skips and bare patches in the tattoo.

I

Idiot: Someone who gets tattooed by a scratcher.

Ink: Pigments placed into the skin during the tattoo process.

Itch: Your new tattoo will probably itch as well as scab.

J

Jailhouse: Also called 'Joint Style'. A style of tattooing developed by inmates. It's the root of black and gray work. The term can also be used in a derogatory sense to refer to a tattoo that lacks sophistication and/or was badly applied.

L

Lines: The work that defines your tattoo. They should be straight and consistent.

Love: (See Vow).

M

Mush: A tattoo that has lost definition, due to bad application, bad aftercare or the ravages of time.

N

Naked: Skin without tattoos.

Name: (See Vow. While you're at it, also see Cover-up.)

Needle: The sharp, pointed thing that connects you with your tattooist.

O

Ointment: Creams used during the aftercare period. (See Itch.)

Old School: Tattooists who served a traditional, formal apprenticeship and adhere rigidly to the tattoo world's codes of behavior.

Oriental: A style of tattooing that utilizes the entire body as canvas.

P

Parasite: (See Scratcher.)

Portrait: A photo-realistic reproduction tattoo of your favorite person or beast.

Primitive: Relating to early times or an original style.

Q

Quiet: What you should be while you're getting a tattoo.

R

Rate: The amount an artist will charge you for your tattoo. Attempting to reduce the rate will only result in an angry tattooist.

Readable: A tattoo that is easily decipherable from a distance.

Realistic: A true-to-life piece.

Rebuff: You will get an abrupt refusal if you come to the studio intoxicated or attempt to lower the artist's prices. (See Rate.)

S

Scratcher: A person who attempts to tattoo, despite the fact that he or she knows nothing about technique or sterilization procedures.

Skin: See Canvas.

Skips: Breaks in the line work or uneven color.

Solid: What your tattoo should be, with no patchy bits of color or shaky line work.

Stencil: A pattern, often made of acetate, used to transfer the design onto the skin.

Sterile: Free from disease-causing organisms. All equipment used during the tattoo process should either be disposable or be sterilized in the autoclave.

Style: Particular genre of tattooing, such as oriental, fineline, etc.

T

Tacked Back: Slang term for being heavily tattooed.

Tat: Pet name for skin art.

Traditional: A style of tattooing that utilizes bold, black outlines, strong, black shading and bright, primary colors.

Tribal: Bold, black, silhouette-style designs.

U

Underground: A tattooist who is either unable or unwilling to work openly. This can be due to a lack of formal training or location in an area that prohibits tattooing.

V

Vow: A vow tattoo is a design that incorporates a name or slogan like 'Mom' 'Betty Sue' or 'Property Of Grizzly'. Most cover-ups are placed over vow tattoos.

W

Wow: The right reaction to your beautiful new tattoo

Y

Yow: Exclamation made by someone who is getting a tattoo on their ribcage.

Yuppies: An annoying group of people who only get a tattoo because it is a fashionable thing to do.

Z

Zero Hour: The designated time of your first tattoo appointment.

TATTOO DIRECTORY

UNITED STATES

NATIONAL ORGANIZATION

NATIONAL TATTOO ASSOCIATION
PO Box 2844
Lehigh Valley
Pennsylvania, 18001

CALIFORNIA

AVALON TATTOO STUDIO
1037 Garnet Avenue
San Diego, CA 92109
619-274-7635

CALIFORNIA TATTOO COMPANY
Artist: Ken Cameron
7946 Auburn Blvd
Sacramento – Citrus Heights,
CA95610
916-723-3559

ED HARDY'S TATTOO CITY
722 Columbus Avenue
San Francisco, CA 94133
415-433-9437

GIL MONTIE'S TATTOO MANIA
8861 W Sunset Blvd
Hollywood, CA 90069
213-657-8282

GOOD TIME CHARLIE'S TATTOO-LAND
3246 W Lincoln Ave
Anaheim, CA 92801
714-827-2071

JOKER'S WILD TATTOO STUDIO
Artist: Nick Cartwright
1605 Pacific Coast Hwy #108
Harbor City, CA 90710
310-534-4532

KARI BARBA'S TWILIGHT FANTASY TATTOO
Artists: Kari, Paul, London,
Joel, Scotty & Marty
3024 W Ball Rd (at Beach)
Anaheim, CA 92804
714-761-8288

CONNECTICUT

GUIDELINE TATTOOS
Artist: Inker
429 Burnside Ave
East Hartford, CT 06108
203-289-2698

THE TATTOO SHOP
Artist: Danny Williams
1753 Barnum Ave
Bridgeport, CT 06110
203-366-1317

HAWAII

SKIN DEEP TATTOOING (WAIKIKI BEACH)
Artists: Art, Winona, Andy,
Calf, Tony, Jennifer, Tony &
Johnny
2128 Kalakaua Ave
Honolulu, HI 96815
808-924-7460

ILLINOIS

BOB OSLON'S CUSTOM TATTOOING
Artists: Bob & Danise
3817 N Lincoln Avenue
Chicago, IL 60613
312-248-0242

BODY BASICS/TATTOOING & BODY PIERCING
Artists: Mad Jack & Mr Max
613 W Briar
Chicago, IL 60657
312-404-5838

GUILTY & INNOCENT
Artists: Guy Aitchison & Phil
Cisco
3105 N Lincoln Ave
Chicago, IL 60657
312-404-6955

INDIANA

PERSONAL ART
Tattooing By Jeanne
3453 Central Ave
Lake Station, IN 46405
219-962-3600

LOUISIANA

ELECTRIC EXPRESSIONS
Artists: Henri, Craig, Skip &
Fernie
2327 Veterans Blvd (Suite B)
Kenner, LA 70062
504-464-0053

MAINE

MAD HATTER'S TATTOO STUDIO
Artists: Lou Robbins, Dennis
Hincks, Ken Fisher &
Tom Dube
50 Old Orchard Street
Old Orchard Beach, ME
04064
207-934-4090

MARYLAND

DRAGON MOON TATTOO STUDIO
208 N Crain Hwy
Glen Burnie, MD 21061
410-768-6471

MICHIGAN

CREATIVE TATTOO/TATTOO AS ART
Artist: Suzanne
307 E Liberty Street
Ann Arbor, MI 48104
313-662-2520

MISSISSIPPI

JACK & DIANE'S KUSTOM TATTOO
1630 Pass Road
Biloxi, MS 39531
601-436-9726

NEW HAMPSHIRE

WHITE MOUNTAIN TATTOO STUDIO
Artist: Gale Mosman
P O Box 820 (Rt 16)
Conway, NH 03838
603-447-3262

NEW JERSEY

THE INK SPOT
Artist: Steve Ferguson
345 Morris Avenue
Elizabeth, NJ 07208
201-352-5777

NEW MEXICO

ROUTE 66
Artist: Brian Everett, Cap & J B
Jones
5511 Central, Old Rt 66
Alba, N MX 87108
505-255-3784

NEW YORK

DARREN AND THE DRAGON CO
New Downtown Location
Call For Appointment Please
212-304-TATU

KALEIDOSCOPE - THE MAGNIFICENT EXPRESSION
Artist: Anil Gupta
New York City
By Appointment
212-274-8006

PAT'S TATS
Ceremonial Tattooing &
Piercing
Artists: Pat Sinatra & Donna
Colelli
Piercers: Pat Sinatra & Steve
Della Ruffa
102 Mill Hill Road
Woodstock, NY 12498
914-679-4429

PORCUPINE
Artist: Emma
Custom Work
By Appointment Only
212-330-9295

SHADOW WORLD TATTOO
Artist: Mike McCabe
Custom Work
By Appointment Only
212-982-8227

OREGON

JUST A TOUCH OF CLASS
Artists: Don, Leif & Marci
826 SW 3rd Ave
Portland, OR 97204
503-225-0454

TEXAS

THE TATTOO SHOP 1 & 2
Artists: Robert & Penny
Hackney, Dave, Chuck & Rev
John #1
3603 Parry Ave
Dallas, TX 75226
214-821-4982

CANADA

LOWER EAST SIDE STUDIOS
Artists: Stu, Bruce & Corey
2234 Kingston RD
Scarboro, Ontario M1N1T9
416-267-7300

MUM'S TATTOO
Artists: Rosalie, Dan & Cam
291 Pemberton Ave
North Vancouver, BC Canada
V7P 2R4
604-984-7831

NEW MOON TATTOO
Artist: Dan Allaston
80 Burland Street
Ottawa, Ontario K2B 6K1
613-596-1790

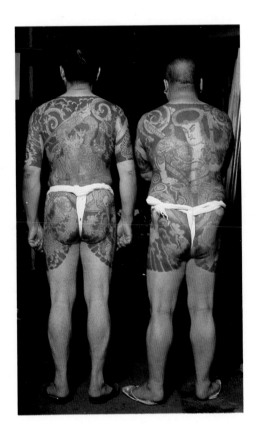

UNITED KINGDOM

NATIONAL ORGANIZATIONS

TATTOO CLUB OF GREAT BRITAIN
Contact: Lionel Tichener
389 Cowley Road
Oxford
0865-716877

ASSOCIATION OF PROFES-SIONAL TATTOO ARTISTS
Contact: Lal Hardy
157 Sydney Road
London N10 2NL
081-444-8779

LONDON

GEORGE BONE
58 Boston Road
London W7
081-579-0831

DENNIS COCKELL
5 Walker's Court
London W1
071-437-0605

LAL HARDY
157 Sydney Road
London N10 2NL
081-444-8779

CENTRAL AND SOUTHERN ENGLAND

AMANDA'S VIKING TATTOO STUDIO
Artist: Amanda Eggleton
1 Victoria Road
Bletchley
Milton Keynes
0908-644393

ART IN THE SKIN
Artist: Lisa
103 Downham Way
Bromley
Kent
081-697-0075

BRENT'S VIKING TATTOO STUDIO
Artist: Brent Eggleton
High Street
North Dunstable
Bedfordshire
05826-63749

TONY CLIFTON
4 Overstone Road
Northampton
NN1 3JH
0604-20644

IAN OF READING
160 Oxford Road
Reading
Berks
0734-598616

DARREN STARES
103A Fratton Road
Portsmouth
PO1 58H
0705-822105

TATTOO MAGIC
Artists: John & Paul
118 Shirley Road
Southampton
0703-331470

LIONEL TICHENER
389 Cowley Road
Oxford
0865-716877

EAST ANGLIA

THE TATTOO SHOP
Artist: Dave Ross
Magdalen Road
Colchester
Essex
0206-766810

THE NORTH

CLEVELAND TATTOO ART CENTRE
Artists: Julie & Mark
York Road
Hartlepool
0429-864025

THE MIDDLETON TATTOO STUDIO
Artist: Louis Molloy
327A Oldham Road
Middleton
Manchester
M24 2DN
061-655-3909

PETE'S TATTOO SHOP
Artist: Pete Colwell
3 Kingsmount
Oxton
Birkenhead
Merseyside
051-653-3505

WALES

ABRACADABRA TATTOO STUDIO
Artist: Dave Fleet
99 Cefn Fforest Avenue
Cefn Fforest
Blackwood
Gwent
Wales
0443-837410

SCOTLAND

TERRY'S TATTOO STUDIO
Artist: Terry Wrigley
23 Chisholm Street
Glasgow
Scotland
041-552-5740

GERMANY

TÄTOWIERSTUDIO
Artist: Sting
Postfach 10 06 03
Buchtstrasse 45
2850 Bremerhaven, Germany
0471-207201

SWITZERLAND

THE LEU FAMILY'S FAMILY IRON
Artists In Residence: Felix & Loretta Leu
Artist On The Road: Titine Leu
34 Rue Centrale
1003 Lausanne, Switzerland

HOLLAND

HANKY PANKY
Oz Voorburgwal 141
Amsterdam
Holland
312-062-74848

AUSTRALIA

EAST SIDE TATTOOING
Artist: Chris Bezencon
118 Vincent Street
Howick
Sydney
612-537-3361

CELTIC DRAGON ART
Artist: Kiwi Kim
41 Enmore Street
Newton
Sydney 2042
612-516-5120

DYNAMIC TATTOOING
Artist: Trevor McStay
Rear 132
Boronia Road
Boronia
Victoria 3155
613-762-4728

The publishers would like to thank the following sources for their kind permission to reproduce the images in this book:

Andrea; Archive Photos; Robert Butcher; CC Riders/Nicki Sharpz; Dennis Cockell; Creative Tattoos; Dermographics of Seattle/Vyvyn Lazonga; Mary Evans Picture Library; Brian Everett; Fine Line/Bill Bolka; Ronald Grant Archive; Robert Harding Picture Library; Hardy; Katz Pictures/Outline/Paul Natkin; London Features International; Roxanne Lowitt; Niall McInerney; Lazlo Pataki; Physical Graffiti/Paul Booth; Primal Urge; Alex Solca; Stings Tatowierstudio; Relay Photos/Steve Schofield, /Mark Webb, /Gene Ambo; Retna/E. J. Camp, /Onyx, /Photofest; Rex Features/John Bradley, /Dave Hogan, /Catherine Leroy; Route 66/Jerry Szumski; Jack Rudy; Trusk International; Universal Fotografia Ltd.

Front cover tattoo: Fip Buchanan/Avalon Tattoo Studio.